IMAGES
of America

JAMES ISLAND

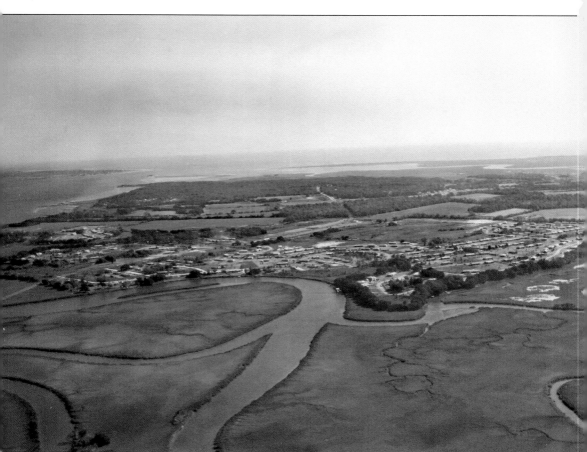

One of South Carolina's many Sea Islands stretching along the state's coast, James Island is a large triangular island located across the Ashley River from the peninsula of Charleston. Nine miles long and from one to seven miles wide, the island is slightly over 35 square miles in size and is framed by Wappoo Creek and Charleston Harbor on the north, Morris Island and Folly Beach on the east, and the Stono River and Johns Island on the west. This c. 1960 aerial photograph shows the expansive marshland and winding creeks of James Island. Along the horizon is the Atlantic Ocean and to the left is Charleston's peninsula and the mouth of Charleston Harbor opening into the Ashley River along the north side of the island. In the forefront, James Island Creek runs from Charleston Harbor into the Stono River, which forms the western boundary of the island, separates it from Johns Island, and ends in the Atlantic Ocean near Folly Island. (Courtesy of Tom and Anne Read.)

ON THE COVER: Whether it is for commerce or recreation, living on the water has always been a significant component of life on James Island. This 1925 photograph of (from left to right) brothers Priestley, Hinson, and Robert Coker on James Island's Clark Sound—taken by their aunt Anna Royall Lebby—portrays a typical afternoon's adventure in one of the island's plentiful creeks. (Courtesy of Anna Lebby Campbell.)

IMAGES
of America
JAMES ISLAND

Carolyn Ackerly Bonstelle
and Geordie Buxton

ARCADIA
PUBLISHING

Published by Arcadia Publishing
Charleston, South Carolina

Printed in the United States of America

Library of Congress Catalog Card Number: 2007937474

For all general information contact Arcadia Publishing at:
Telephone 843-853-2070
Fax 843-853-0044
E-mail sales@arcadiapublishing.com
For customer service and orders:
Toll-Free 1-888-313-2665

Visit us on the Internet at www.arcadiapublishing.com

For tour information, visit www.walksinhistory.com

This book is dedicated to the memory of family:

Julian Thomas Buxton Jr., M.D.

George Chester Bonstelle Jr.
Edith von Glahn Bonstelle
Edith Williams von Glahn

With love and honor,

Geordie and Ackerly

CONTENTS

ACKNOWLEDGMENTS

This book would not have been possible without the combined time, interest, and information shared with us by so many people. The support and generosity shown to us was a true testament to the hospitality of James Islanders and to those who are eager to preserve history. To these people we are so indebted and grateful.

Photographs were graciously contributed by Dorothy Ellen Royall Ariail, the Avery Research Center, Thomas Backman Jr., Capt. Sandiford Stiles Bee Jr., Karen Clark Bennett, Anne Wallace Buxton, Clyde Bresee, Anna Lebby Campbell (from the collection of her great aunt Anna Royall Lebby), Mary Oswald Godbold Davis, the Reverend Hercules and Mildred White Champaign, Mary Clark, Daniel Wordsworth Ellis IV, Frances Robinson Frampton, Friends of McLeod (Tom Delaney and Carol Jacobsen), Mary Seabrook Oswald Godbold, William Goss, Perry Grant, Edward LaRoche Grimball, Pauline Mikell Grimball, Amelia E. Jenkins, Willis J. Keith, Robert Lebby, Lucy Buxton Lukens, Gresham and Carole Meggett, John Jerdone Mikell, Anna Pruitt, Theresa Backman Richardson, the South Carolina Confederate Relic Room and Military Museum (Columbia, S.C.), the South Carolina Room at the Charleston County Public Library, Lavinia Mikell Thaxton, Frances Mikell Tupper, Tom and Anne Read, William Hinson Royall Jr., Mary Rivers Ellis Staats, and Robert Ellis Welch.

We would also like to thank the following for their input, encouragement, and research assistance: Dr. W. Marvin Dulaney, Harlan Greene, Jessica Lancia, Georgette Mayo, and Deborah Wright from the Avery Research Center; Mike Coker from the South Carolina Historical Society; Libby Wallace from the Post and Courier Research Library; Molly French from the South Carolina Room at the Charleston County Public Library; Joyce Baker and Eliza Buxton from the Gibbes Museum of Art; Kristina Dunn from the South Carolina Confederate Relic Room and Military Museum; Kellen Correia from Friends of the Hunley; the Beaufort County Library; Anne von Glahn Bonstelle; Priestley C. Coker III; Annie Buxton Misic; George Prioleau; Steven Sandifer; Mikell C. Thaxton; Edith Williams von Glahn; Willis J. Keith, "Skipper," for imparting his indispensable wisdom and James Island knowledge; and Maggie Bullwinkel, our editor.

INTRODUCTION

During the creation of this James Island photographic history book, a 1919 photograph (see top of page 101) was provided by Anna Lebby Campbell from the collection of her great-aunt, Anna Royall Lebby. The rustic photograph is fairly modern compared to many in this book. At the same time, the lives of all of the family members who are pictured have expired. The image is zoomed in so closely to the family that only the porch is visible in the background.

There are 14 people seated on the wooden steps of the porch. At the top of the steps, behind many generations of well-dressed family, an ancient-looking woman sits in a rocking chair. A young boy wearing a black cap is sitting below her. He is holding a Boykin spaniel up with both arms, struggling to face his beloved pet's eyes toward the camera. One can only imagine how many mallards, marsh hens, or turkeys that dog chased across the island.

The side of the ancient woman's head and neck are in the light, while the remainder of her face is shadowed by the porch awning. She appears to be looking off to the left through the shadow. In the distance, behind the red tin–roofed Seaside Plantation house, stands the 1876 Morris Island lighthouse at the Clark Sound inlet. The woman's view through the sprawling live oaks must have been majestic as the sun set on James Island that Thanksgiving in 1919. At her age, she would have been viewing the lighthouse in its prime, brightly lighted and securely on land. She likely remembered its construction in her youth after Confederates purposely destroyed its predecessor to hinder Federal ships from navigating the waterways during the War between the States.

The water carried indigenous tribes and foreign nationals from Europe and Africa to James Island's shores. The push-and-pull rhythm of Atlantic Ocean tides have molded the sandbars, inlets, and creeks. When a person jumps off a dock into Clark Sound, he or she enters some of the richest tides of marine life on Earth. From the tiniest scurrying fiddler crabs across black pluff mud, to flounder floating motionless through the creeks, to the playful leaping dolphins, the water has offered a continuous life-force to James Island's identity.

While the water carried the first inhabitants to the island, it has also carried their multifaceted exports (Sea Island cotton, produce, dairy products, and other goods) to the docks of Charleston and around the world. James Island is on the southern side of the entrance to one of the largest Atlantic seaports today. Sol Legare Island near Folly Beach is proof that James Islanders continue to keep the religion of fishing alive. Fantastical maritime stories originate from this predominantly Gullah-influenced southwestern reach of the island. In 1953, a 3,000-pound devilfish was pulled ashore by Capt. Thomas Backman, followed years later by a 13-foot Tobasco shark. James Islanders, from African descendants along Mosquito Beach on Sol Legare, to European descendants along the harborside, have always savored the rich bounty of oysters, crabs, shrimp, and deep-sea fish.

This 1919 photograph shows an infant sitting in a smiling mother's lap on the bottom step of a plantation house. The baby's hands are raised in the sunlight. Like the ancient woman in the rocking chair, the little one appears to look away in the direction of the sun and lighthouse. The infant experienced an entirely different era than the family matriarch. Behind the Seaside Plantation house on Clark Sound, where most recently tomato fields existed, dozens of larger, modern brick homes with winding concrete driveways have intruded. The simple agrarian dream, which only a few decades ago still survived, has altogether disappeared, save for the shape of the marsh and the original house. Though this plantation, along with James Island's many others, has given way to development, the marsh and saltwater surrounding the affluent neighborhood carry more historical treasures than all the memories in those new homes combined.

The tides that run beneath the docks of James Island still carry the memories of the lives of those who have passed through—the Stono and Wappoo natives, pirates, Spaniards, Frenchmen, English, Africans, and Americans who, through much adversity, made James Island the place it is today. While men and women tilled the fertile James Island soil and fished in its creeks through

the centuries, the same species of sea eagles and marsh-dependent life inhabited the area. Today the land is a vibrant amalgamation of many cultures in touch with the island.

The herons, seagulls, and fiddler crabs moving across the black mud flats of the island's marshes are silent descendants of ancestors that witnessed agrarian peace at the peak of the plantation era as well as some of the most violent times in American history. From the early colonial battles with natives, to the Revolutionary War and the War between the States, James Island can claim a considerable series of conflicts in the shaping of this nation's history.

This James Island book assists in documenting what once was and what will never be again. From the plantation remains of Lawton Bluff, Stiles Point, and McLeod that have survived since the 18th century, to the endangered Morris Island lighthouse, James Island's distinct character and regional singularity will hopefully remain intact by raising awareness of the need for preservation. This book illuminates a people who lived off of the land and water. They grew and caught most of what they ate. In every way, the land and agrarian way of life is what James Islanders have fought for. Defiance to the outside world has always been a part of James Island's identity. Many low-lying marsh areas, such as Sol Legare Island and tracts along the Wappoo and Stono Rivers, are still in need of protection to thwart developers and their gluttonous appetite for land.

Author Clyde Bresee was so moved during his time spent on James Island's Lawton Plantation in the early 20th century that he has contributed more literary work regarding the area than any other author with his books *Sea Island Yankee* and *How Grand a Flame*. He has likened a newcomer's arrival on James Island to entering "a whole other society or culture altogether." This esteemed author, who now resides in Athens, Pennsylvania, is one of many people who deserve acknowledgment for helping us create this book.

Our book includes the island's original churches, James Island Presbyterian and St. James Episcopal, as well as its early schools, while touching on some of the more recent establishments such as the Marine Resources Research Center at Fort Johnson. We were astonished to learn while interviewing and collecting photographs that a full education on James Island is a surprisingly recent idea. Until the opening of James Island High School in 1954, the highest education one could attain on James Island was at the eighth grade level. Sons and daughters of James Islanders who could not afford to drive a boat or car to downtown Charleston were forced to begin their trades or callings at an early age.

Historically, James Island access has been by boat. The first modern bridge to James Island was a drawbridge constructed in 1926 across Wappoo Creek. In 1992, a four-lane fixed bridge was built from Harborview Road to Charleston, making the island a seven-minute drive from downtown. Since then, James Island has seen increased commercial and residential development. It continues to struggle to reconcile its heritage, the land, and the influx of new residents.

We have attempted to encompass many of the personalities that created the island's sense of community. Established family names like Bright, Brown, Frazier, Lemon, Prioleau, Richardson, Simmons, Singleton, Washington, and many more have untold stories and photographs that are still yet to surface. A reader will also find other prominent names such as Clark, Frampton, Lawton, Legare, Rivers, and Seabrook interspersed a little less densely. This book may leave many wanting to find out more about these iconic James Islanders—and this is our desire. While we were unable to document all the branches of the many family trees that constitute James Island society, we hope that these incredible photographs will inspire others to search, dig, and even publish the historic treasures we have undoubtedly missed. We know much history is still out there.

—Geordie Buxton
July 7, 2007

One

JAMES TOWN

In 1671, a colony of 12,000 acres was established along James Island Creek. This settlement, the second in South Carolina, was named James Town in honor of James II, brother and heir of King Charles II of Great Britain. Charlestown, the first permanent settlement in South Carolina, had been named for King Charles II the previous year. The colony of James Town established the roots for what would eventually become James Island. Hitherto, James Island was an untamed land inhabited by native tribes, particularly the Stono and Wappoo, as well as by transient pirates.

The island was the backdrop for the first lighthouse in South Carolina (now the Morris Island lighthouse) to the port of Charlestown in 1673. During this time, a grove of pines known as Hundred Pines became one of the earliest recognizable landmarks from the harbor. Enslaved Africans from the Windward Coast dominated the island's population in its first two centuries of existence, as plantations required an increasingly large labor force. While it is an understatement that plantation life had a degrading and inhumane side, it also generated an often unmentioned bond between the two primary cultures through their cultivation of the land and the water. Even today, one can discern vestiges of the Gullah dialect when listening to the speech of many James Islanders, both white and black.

Towering live oaks and pines were encroached to create land for livestock, produce, and cotton. James Island shipbuilders thrived during the mid-1700s as they crafted vessels for wealthy local planters and merchants, as well as for English merchants, at the James Island Shipyard. The island is less than a mile from the first major Revolutionary War colonial victory, which was won over the harbor on June 28, 1776, a date now known as Carolina Day. Later in the war, the British built the Watermelon Battery at James Island's Stiles Point to shell Charlestown during their siege of the city from February to May 1780. After the British were expelled from Charlestown, the first cotton mill in South Carolina—and possibly the first in America—was established by Frances Ramage on James Island in 1789. Commerce languished as the British returned to blockade the harbor during the War of 1812, reducing many of the island's plantations to poverty. The life of the harbor returned to normal, and James Island's plantation society flourished through most of the 19th century leading up the firing of the first shots of the War between the States on April 12, 1861, from Fort Johnson at the northeastern tip of the island.

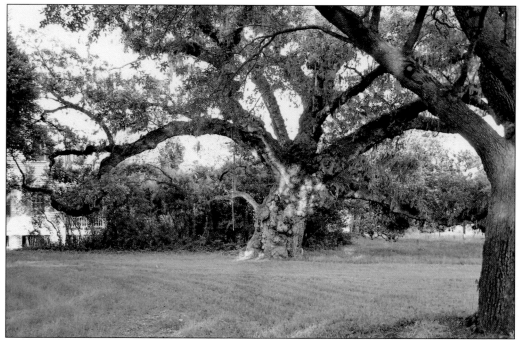

James Island is known for its abundance of ancient live oak trees, which provide much welcome shade during the hot summers. The McLeod oak (above) on McLeod Plantation is estimated to be 1,000 years old, making it the second oldest in South Carolina—neighboring Johns Island's Angel Oak, which exceeds 1,450 years in age, is known as the oldest. (Courtesy of Friends of McLeod.)

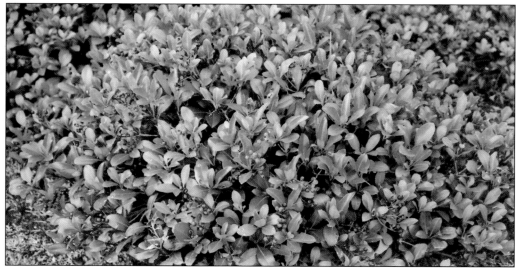

The *Cassine Ilex*, or "Cassina," a red-berried holly, grows in abundance near the salt water creeks and rivers of James Island. From this thriving shrub, the island's native tribes made their Black Drink, a tea used in male-purification rituals. It resembles Chinese tea in both taste and smell. The "mate" or "Paraguay tea" that is a popular drink in South America is also an ilex or holly. (Courtesy of Carolyn Ackerly Bonstelle.)

Some of the oldest native pottery artifacts in North America were found in July 1930 at James Island's Lighthouse Point, owned by Stiles Bee, "Sandy," when a large, dense ring of shells was excavated. The artifacts are believed to date to early in the second millennium. Aboriginal remains proliferated on the southern and eastern shores of James Island, where oyster, clam, welks, and periwinkle shells reveal foods of the native tribes, who derived the bulk of their protein from deer. This c. 1930 photograph was taken by William Henry Johnson, 300 yards from the "Three Trees" landmark. The uncovered Indian ring was 240 paces in size, composed of the above mentioned shells and interspersed with deer bones and antlers, mixed with quantities of ashes. Ring-shaped middens—mounds of debris containing shells, animal bones, and other remains indicative of human settlements—such as this are found only on the coasts of South Carolina and Georgia. (Courtesy of the South Carolina Historical Society.)

James Island's "Three Trees" landmark, a triangular area formed by three ancient live oak trees near the entrance to Lighthouse Point, is reputed to be where coastal native tribes settled their differences by utilizing the peace-pipe as a diplomatic tool. The Cassiques, or *chiefs*, of the Stono, Wappoo, Bohicket, and Kiawah tribes were sometimes female. The coastal tribes, referred to as "Cusabo" by the English, had shamans or conjurers and paid homage to ancestral spirits. (Courtesy of the South Carolina Historical Society.)

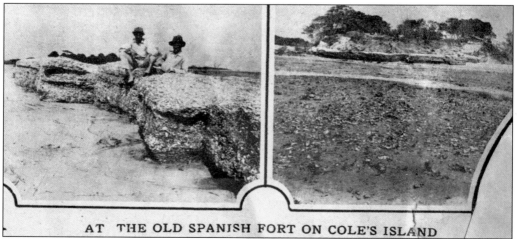

AT THE OLD SPANISH FORT ON COLE'S ISLAND

The initial explorers and temporary settlers of South Carolina arrived in the 1500s from Spain and France. The first attempt to establish a settlement in the state was made by the Spanish in 1526 at Winyah Bay near present-day Georgetown but failed because a harsh winter and Native American attacks. The 1562 French effort to settle near Beaufort was also unsuccessful. Charles Towne Harbor was called St. George's Bay on a 1526 map, and the Spanish first recorded contact with the native Stono (Ostano, in Spanish) tribe in 1609. Although the attempted settlements of Spain and France in South Carolina did not flourish, these two countries periodically contested England's claim to the region. This *c.* 1920 newspaper photograph of a Spanish fort on Cole's Island—one of James Island's many neighboring islands—shows Spain's reluctance to forfeit its claim to the territory. (Courtesy of the South Carolina Historical Society.)

12

JAMES II.

The first permanent European settlement in South Carolina, Charles Towne—now called Charlestown—was established by English colonists on the bank of the Ashley River at Albemarle Point in 1670. In 1680, the Albemarle Point site was abandoned, and Charles Towne was moved to its current peninsular location for defensive purposes. In 1671, the provincial council ordered a second settlement to be established on the northern bank of James Island Creek. This town was known as James Town after James II, the Duke of York, brother to King Charles II, and eventual heir to the British throne. The exact site of James Town is unknown except that it was on James Island Creek. James Town was designated a "colony" of 12,000 acres with each settler allotted a half acre for a residence in the town and 10 acres for planting. Larger tracts were granted for plantations along New Town Creek (James Island Creek). These first settlers included 40 Dutch New Yorkers—23 white and 17 black. No plat of James Town has survived in public records, and the last mention of the town on maps or transcripts was in 1686. For a short period in the early 1690s, James Island was called Boone's Island, probably for John Boone, one of the first settlers of South Carolina, who received a 1,500-acre grant for land on the island before being expelled by the Lord's Proprietors in 1691 for his supposed dealings with pirates. The name James Island appeared in public documents in 1693. (Courtesy of the Library of Congress.)

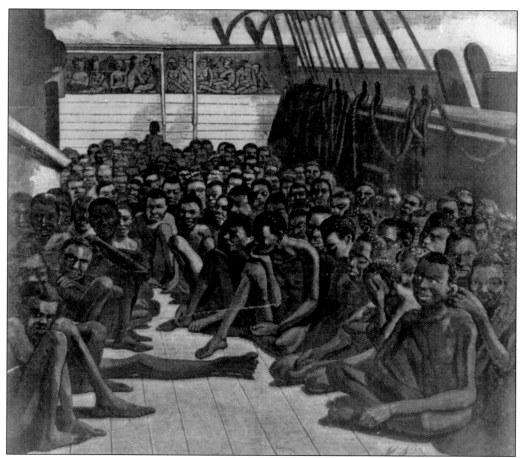

During the era of the Atlantic slave trade in North America—lasting from the mid-17th century until 1865—nearly half of the enslaved Africans arriving in this country came through the port of Charleston between James Island and Sullivan's Island. Sullivan's Island, across the mouth of the harbor from James Island, has been called the "Ellis Island of African America." The Africans were involuntarily brought mainly from West and Central Africa. This system of exploitation began in the early 16th century, with its origins lying in the European need for laborers to sustain their plantation economies. The 17th century European settlers of James Town brought many Africans to live with them, and with the success of the early colonial Sea Island plantations and an increased need for more laborers, the population grew to the point where Africans vastly outnumbered whites on James Island in the 18th and 19th centuries. This 1860 illustration depicts the slave deck aboard a slave ship bound for America, with African men crowded onto a lower deck and African women on the top deck. Because of their skills and knowledge of agriculture, many of the Africans purchased were from the "Windward Coast" region of West Africa, and they brought much of their African heritage with them. Throughout the Sea Islands of South Carolina and Georgia, slaves merged elements of their West African linguistics (especially that of Sierra Leone) with English, creating the Gullah language. The Gullah people retained many of their African cultural traditions, including oral recitation, spiritual music, folk beliefs, and cuisine. Today many traditional Lowcountry dishes—okra gumbo, red rice, she-crab soup—are derived from African cuisine. Because of the relative geographical isolation of the Sea Islands, the Gullah descendants have been able to preserve more of their African heritage than any other group of African Americans. (Courtesy of the Library of Congress.)

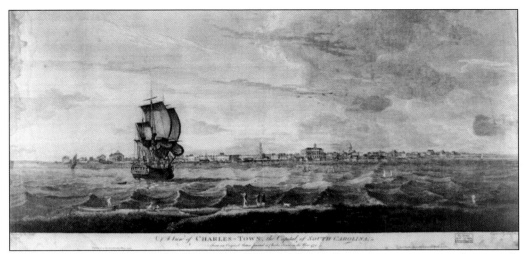

In the 18th century, James Island was as well known for its ship carpentry as it was for its early plantation produce. Schooners, sloops, and masts were built at the James Island Shipyard from 1742 to 1772. The coastal residents of the many different cultures—Native American, African, and European—combined their skills to produce some of the finest colonial American ships for prominent local and English merchants and investors. This 1774 print of a ship in Charles Towne Harbor provides a distant view of the city of Charles Towne, then the capital of South Carolina. Due to its strategic location between the harbor and the Stono River, James Island has played a significant role throughout Charleston's maritime and military history. (Courtesy of the Library of Congress.)

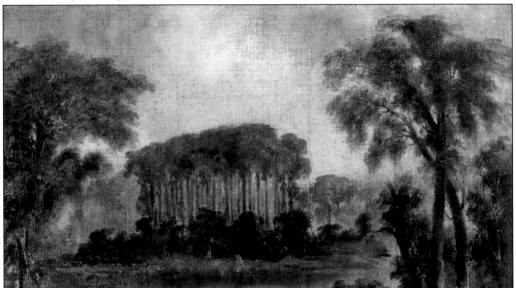

This grove of pines on James Island's northern shore came to be known as "Hundred Pines" and was one of the first landmarks along the James Island shoreline used by mariners in finding the elusive opening to James Island Creek from the Charles Towne Harbor. A young French artist, Augustus Paul Trouche, who arrived in Charleston in the early 1800s, painted this image of Hundred Pines on canvas. (Courtesy of the Gibbes Museum of Art.)

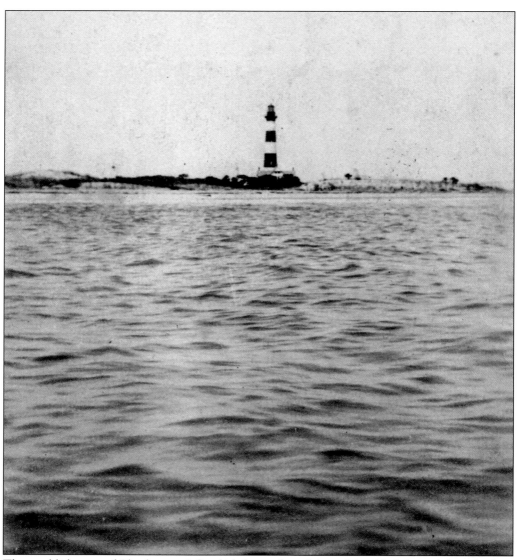

The establishment of Charlestown's first lighthouse (now Morris Island lighthouse) dates back to 1673, at which time the beacon was a primitive iron basket with wood burning inside. Mariners who left the harbor at night were asked to contribute wood to the fire in order to keep it burning through the night. Later, sperm whale oil was used. In 1767, the first Charlestown lighthouse was constructed by the British colony of South Carolina to aid navigation in the port. In 1837, the lighthouse was replaced by a new construction at a different location and was shortly after destroyed by the Confederates to prevent Federal troops from using it during the War between the States. A new lighthouse (the structure above) was constructed in 1876. In the past century, due to rapid land erosion on Morris Island caused by the placement of two jetties at the mouth of Charleston Harbor, the lighthouse has lost the surrounding land supporting its foundation, placing it in jeopardy. Today residents along James Island's Clark Sound enjoy the view of this lighthouse. Although situated on Morris Island, the lighthouse has always been a part of James Island's identity, because it defines the northern tip of the island's landscape. (Courtesy of Dorothy Ellen Royall Ariail.)

During the War of Spanish Succession, James Island was invaded by Spanish and French troops who ravaged the countryside in 1706. As a result of this invasion, one of the first fortifications erected to defend the entrance to Charlestown Harbor was constructed at Windmill Point. Named for Sir Nathaniel Johnson, governor of the Province of Carolina from 1703 to 1709, Fort Johnson was built in 1708. It is located on the northeast point of James Island, approximately three miles southeast of Charleston. A second fort was added in 1759. In 1780, during the Siege of Charleston in the Revolutionary War, as General Prevost advanced his British troops across James Island, Americans from Fort Johnson entrenched themselves in trenches known as "Wolf Pits" in front of what is now Payne R.M.U.E. Church, and this vicinity between the fort and the church, to this day, is known as Wolf Pits Run. Upon arriving at Fort Johnson, the British found it abandoned and partly destroyed, as the colonials had retreated to Charleston. A third fort was added to the original site in 1793. The Fort Johnson site was most notably used in 1861 as Confederate forces erected mortar batteries to fire upon Federal troops at Fort Sumter beginning the War between the States. (Courtesy of Willis J. Keith, with permission from the Library of Congress.)

The Watermelon Battery was a battery of two guns constructed by the British on James Island in the spring of 1780 during their siege of Charlestown in the Revolutionary War. This battery was located to the west of Fort Johnson and slightly east of the Hundred Pines on the property of Benjamin Stiles. In April 1780, British troops firing upon Charleston from the Watermelon Battery shot the arm off of the statue of William Pitt that then stood on Broad Street. (Courtesy of the South Carolina Historical Society.)

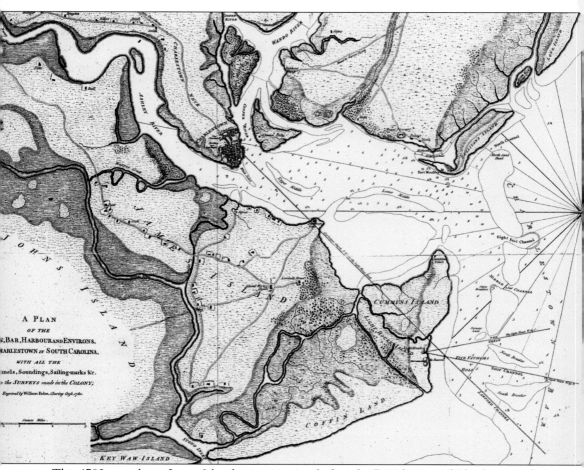

This 1780 map shows James Island properties just before the British siege of Charlestown during the Revolutionary War. Fort Johnson, which played an integral role during the war, is depicted on the northeast side of James Island at the mouth of the Charlestown Harbor. The Morris Island lighthouse, Fort Johnson on James Island, and St. Phillip's Church in downtown Charlestown served as three ranges to guide mariners into the port city. (Courtesy of Friends of McLeod.)

Two

WAR BETWEEN THE STATES

The violent conflict that engulfed America from April 1861 until June 1865 claimed the lives of over 618,000 American soldiers. This war has historically been known by many names, each reflecting the specific historical, political, or regional sensibilities of various groups. The most enduring of these are the Civil War and the War between the States, the latter being the Southern term of preference. More partisan names such as the War of Northern Aggression, the War for Southern Independence, and the War of the Rebellion have not been forgotten.

When South Carolina became the first state to secede from the Union on December 20, 1860, a total of 10 other states closely followed, culminating as the Confederate States of America. The first shots of the War between the States originated from South Carolina's Fort Johnson, on the northeastern tip of James Island. All James Island civilians were ordered to evacuate the island in May 1862 by Confederate general John Pemberton. With the exception of an amphibious assault on Fort Johnson by the Federals from Morris Island on July 2–3, 1864, most of the major fighting on James Island took place on its shores and along the Stono River, including battles on June 10, 1862, June 16, 1862 (the Battle of Secessionville), July 10, 1863, and February 10, 1865.

James Island's McLeod Plantation house was occupied by both Confederate and Federal forces during the hostilities. Following the Confederate surrender of Charleston's defenses on February 17–18, 1865, Federal forces occupied the island until 1879. When Gen. Robert E. Lee surrendered the Confederacy, the lands and homes of James Island planters were left in ruins. Only six of the island's plantation houses remained at the conclusion of the war: McLeod, Stiles Point, the Heyward-Cuthbert House on Lawton Plantation, White House, Secessionville Manor, and the home of Edward Freer at Secessionville.

Following the war, McLeod Plantation was used as a Freedman's Bureau as freedmen took refuge on the property of their former masters anticipating to be given a piece of land to call their own. Despite the devastated economy and land, little changed the agrarian-oriented nature of life on the island during the century after Emancipation. However distant it may seem, the significance of the War between the States remains evident on James Island even today, almost 150 years since its conclusion. Thus when native James Islanders allude to "The War," one need not question the war to which they are referring.

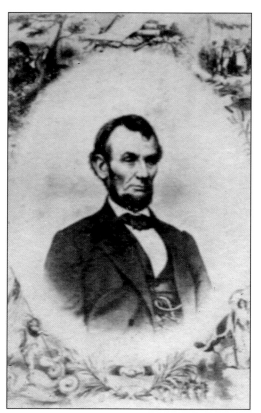

"Any people, anywhere, being inclined and having the power, have the right to rise up and shake off the existing government, and form a new one that suits them better. This is a most valuable and most sacred right—a right which we hope and believe is to liberate the world. Nor is this right confined to cases in which the whole people of an existing government may choose to exercise it. Any portion of such people, that can, may revolutionize and make their own of so many of the territory as they inhabit." Abraham Lincoln, the 16th president of the United States, had radically different views 12 years before the War between the States, as evinced in this quote from his January 12, 1848, speech to Congress advocating peaceful secession. But as issues over trade, the tariff (which favored Northern industry and left the agrarian South at an economic disadvantage), the Southern desire to expand slavery to the western territories, and states' rights became more heated, Southern states began to view secession from the Union as their only option. Lincoln and other politicians were forced to choose sides. Pictured is an original calling card of Abraham Lincoln. (Courtesy of Lavinia Mikell Thaxton.)

Pierre Gustave Toutant Beauregard commanded the James Island forces that bombarded Federal troops at Fort Sumter on April 12, 1861. Born in New Orleans, he eventually became one of the eight full generals of the Confederacy and was involved in almost every important theatre of the war. Beauregard wrote two books during the war: *Principles and Maxims of the Art of War* (1863) and *Report on the Defense of Charleston* (1864). After the war was over, he returned to New Orleans. (Courtesy of the Library of Congress.)

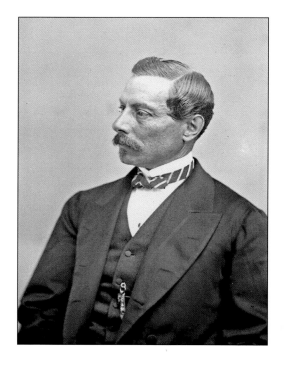

Under the command of Confederate captain George S. James, at 4:30 a.m. on April 12, 1861, the first shell of the War between the States was fired from Fort Johnson's "East" or "Beach" Battery upon Fort Sumter. Having just received the directive from General Beauregard, Captain James issued the order for Lt. Henry S. Farley to fire. The first shot from James Island's Fort Johnson was followed by a 33-hour Confederate bombardment on Fort Sumter. The War between the States, a devastating four-year war that would eventually claim the lives of more than 618,000 American soldiers, had officially begun. Federal major general Robert Anderson surrendered and evacuated Fort Sumter on April 14, 1861. (Courtesy of the South Carolina Confederate Relic Room and Military Museum, Columbia, SC.)

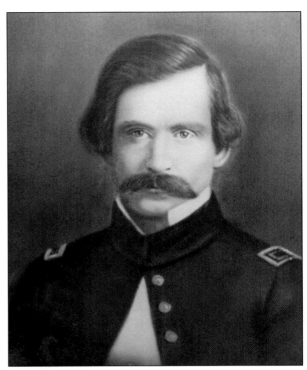

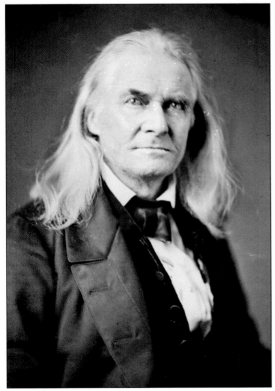

Following the first shots from Fort Johnson, 67-year-old Edmund Ruffin, a fervently secessionist Virginia planter, fired the first shot from Stevens Iron Battery on Morris Island, just north of James Island. Having left Virginia because of his state's hesitance to secede from the Union first, he traveled to South Carolina, which became the first state to secede. Years after the devastation on James Island and the fall of the Confederacy, Ruffin returned to Virginia, wrapped himself in a Confederate flag, and took his own life. (Courtesy of Richard Rhett Knoth with permission from the Library of Congress.)

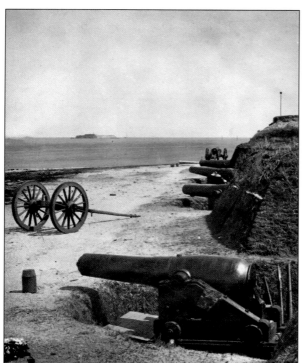

These 1865 photographs, taken after the Federal occupation, show Fort Johnson while it was still intact following the War between the States. Fort Sumter, which was bombarded for 33 hours by the Confederates at Fort Johnson to begin the war, is in the distance. The "water battery" of Fort Johnson (above) was constructed in 1863 and mounted two 10-inch Columbiads, a 7-inch Brooke rifle, and a 10-inch banded rifle—the largest cannon on James Island. Fort Johnson was a strategic point on James Island in one of the war's bloodiest battles, the Battle of Secessionville, in 1862. By 1865, Fort Johnson was defended with 27 pieces of artillery. All that remains today on the site of these extensive fortifications is a brick powder magazine originally constructed in 1814. (Courtesy of Willis J. Keith with permission from the Library of Congress.)

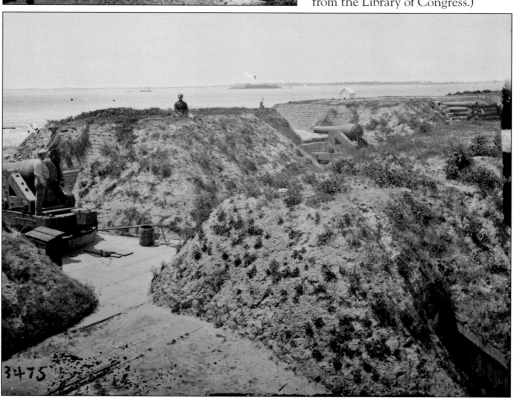

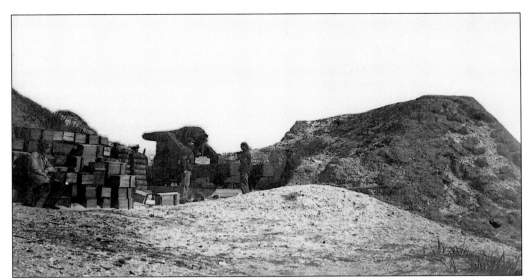

To protect the approaches to Charleston, Confederate forces built defenses across James Island. Fort Johnson was flanked on the right by the single-gun Brooke Battery (above) and Battery Simkins. Battery Harleston was adjacent to Fort Johnson. (Courtesy of the National Archives.)

Battery Glover, to the left of Fort Johnson, was positioned at Stiles Point at approximately the same location as the 1780 British Watermelon Battery. There were also two guns in Battery Means, on the current Country Club of Charleston grounds, for the defense of Wappoo Cut. (Courtesy of the Beaufort County Library.)

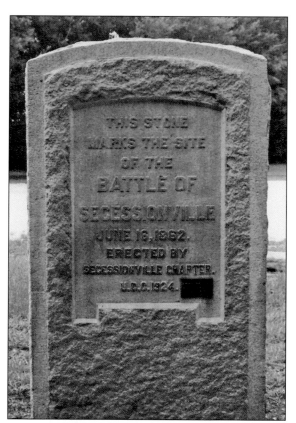

On June 2, 1862, 7,500 Federal troops under the command of Brig. Gen. H. W. Benham landed on James Island's Grimball Plantation along the Stono River. Two weeks later, on June 16, the James Island planters' summer home community of Secessionville became the scene of a decisive victory for the Confederates, when 3,500 of these troops engaged in an effort to take the earthen fortification known as the "Tower Battery." Attempting to capture Charleston by land, Benham marched his men to an unsuccessful attack on the Confederate fort at Secessionville, defended by less than 500 Confederates under Col. T. G. Lamar. The Federal troops lost 683 men in the repulse, while the Confederates lost 204. The Battle of Secessionville was perhaps the most significant battle of the war in South Carolina. The "Tower Battery" was later enlarged and named Fort Lamar (pictured below). (Above, courtesy of Carolyn Ackerly Bonstelle; below, courtesy of Geordie Buxton.)

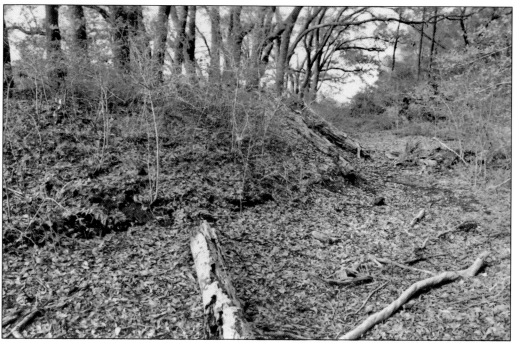

Gen. John C. Pemberton assumed command of the Confederate forces of South Carolina, Georgia, and Florida in February 1862. That spring, he underestimated the importance of the defense of Charleston when he made the decision to withdraw all troops and artillery from Fort Palmetto on Cole's Island, opening the mouth of the Stono River and western flank of James Island to Federal invasion. Federal troops quickly took over the abandoned fort and attacked James Island a month later from that position in the Battle of Secesionville, and again in July of 1863 in the Battle of Sol Legare Island. Pemberton, born in Pennsylvania and trained to become a general in Virginia, was disliked by James Islanders because of his military strategy, which left the island vulnerable to attacks. His rationale for ordering the evacuation of James Island was that it was indefensible. Pemberton was replaced by General Beauregard in October 1862 and is best known for his unsuccessful defense of Vicksburg, Mississippi. (Courtesy of the Library of Congress.)

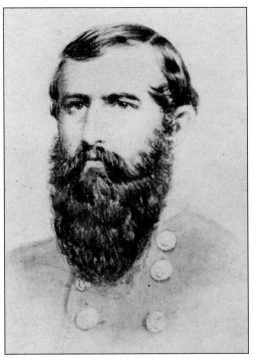

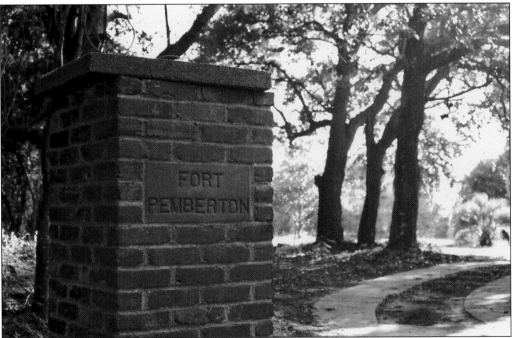

General Pemberton oversaw the construction of the defenses built across James Island in 1862. Fort Pemberton, in present-day Riverland Terrace, was a large pentagonal shaped earthwork constructed to defend the Stono River at Eliot's Cut, blocking off the Federals from further access up the Stono River from Beaufort and the Atlantic Ocean. (Courtesy of Geordie Buxton.)

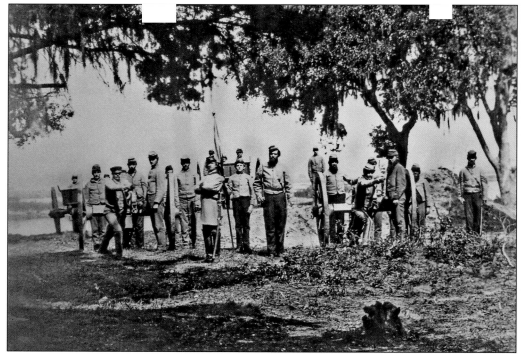

This Palmetto Light Artillery, stationed on James Island, was one of the many Confederate companies formed prior to and during the war. This *c.* 1863 photograph was most likely taken at Fort Pemberton along the Stono River, in today's Riverland Terrace area. (Courtesy of Willis J. Keith.)

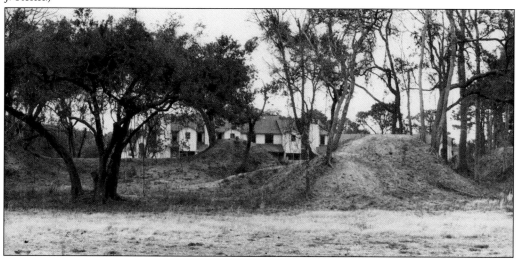

The earthwork designated Battery No. 5, built overlooking Seaside Creek and Secessionville, was once occupied by 110 Confederate soldiers who used small arms and four cannons to defend Charleston against an attack by Federal troops assaulting James Island from the Stono. This battery was the easternmost position of the James Island Siege Line, on which construction commenced during the summer of 1863 under the command of General Beauregard. (Courtesy of the *Post and Courier*.)

The Confederate lines of defense on James Island in the summer of 1863 extended from Fort Pemberton in Riverland Terrace to Secessionville. Planning to drive the Federal gunboats down the Stono River to where they could not protect their forces who had landed on James Island, Confederate forces moved from Secessionville onto Sol Legare Island on July 16, 1863, engaging members of the African American 54th Massachusetts Volunteer Infantry. Following the Battle of Sol Legare, the 54th Massachusetts Company left for the attack on Battery Wagner on July 18 without rest or food. (Courtesy of Geordie Buxton.)

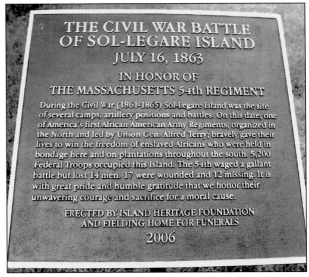

THE CIVIL WAR BATTLE OF SOL-LEGARE ISLAND
JULY 16, 1863

IN HONOR OF
THE MASSACHUSETTS 54th REGIMENT

During the Civil War (1861-1865) Sol-Legare Island was the site of several camps, artillery positions and battles. On this date, one of America's first African American Army Regiments, organized in the North and led by Union Gen. Alfred Terry, bravely gave their lives to win the freedom of enslaved Africans who were held in bondage here and on plantations throughout the south. 5,200 Federal Troops occupied this Island. The 54th waged a gallant battle but lost 14 men. 17 were wounded and 12 missing. It is with great pride and humble gratitude that we honor their unwavering courage and sacrifice for a moral cause.

ERECTED BY ISLAND HERITAGE FOUNDATION
AND FIELDING HOME FOR FUNERALS

2006

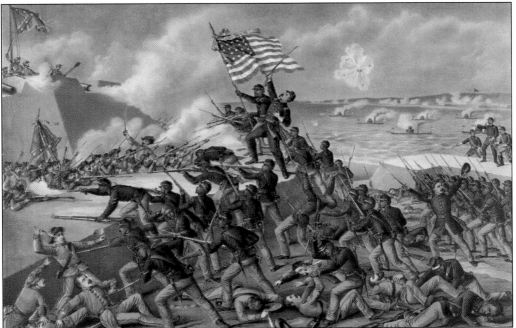

Fort Wagner, a fortification on Morris Island covering the southern approach to Charleston Harbor, was the site of two battles during the War between the States in 1863 in the campaign known as "Operations against the Defenses of Charleston." In the first engagement of July 11, 1863, the Confederates sustained 12 casualties, as opposed to the 330 casualties suffered by the Federals. Depicted in the above painting is the second battle on July 18, 1863, in which Federal forces, led by the 54th Massachusetts Volunteer Infantry—one of the first American military units consisting of free African American soldiers—under Col. Robert Shaw, stormed the Confederate fort. Although a tactical loss for the Federal troops, the valor and determination of the regiment proved the worth of African American soldiers and inspired others to enlist. (Courtesy of the Library of Congress.)

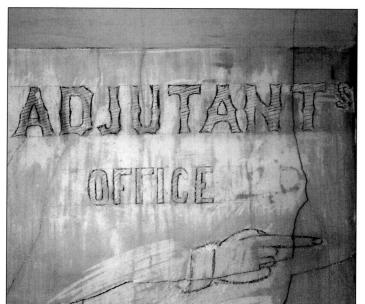

During the war, James Island's McLeod Plantation was used by Confederate forces as a regimental headquarters, a commissary for the island's troops, and as the division hospital. Evidence of the Confederate occupation of the McLeod house remains today where "Adjutant's Office" was marked on one wall, perhaps referring to the office of Confederate general Gist's administrative assistant. (Courtesy of Friends of McLeod.)

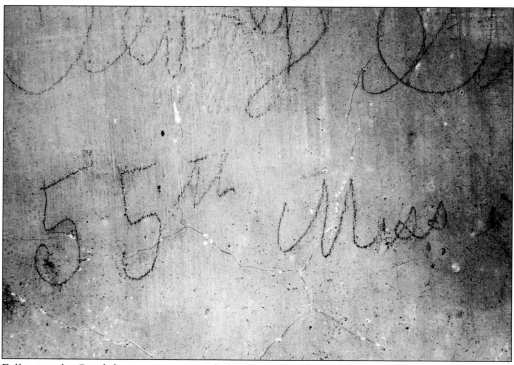

Following the Confederate evacuation of Charleston (and James Island) in February 1865, Federal forces began to occupy McLeod Plantation as their headquarters on the island, using the main house as a hospital and as officers' quarters. During this time, the 54th and 55th Massachusetts Volunteer Infantries were stationed at McLeod. Evidence of the Federal occupation also remains in the McLeod house in the form of a signature inscribed in the attic by George Smothers, a soldier of the 55th Regiment. (Courtesy of Friends of McLeod.)

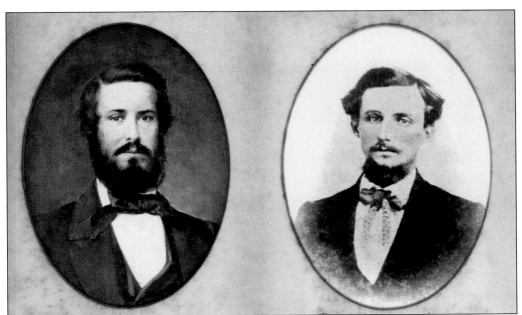

Of the many James Island men who fought to protect their families, homes, and way of life during the war, approximately 16 lost their lives. Among these were Stiles Mellichamp Hinson (above left), the eldest son of Joseph B. Hinson and Juliana B. Rivers, and the brother of W. G. Hinson, who was killed on August 14, 1864, at Fussel's Mill, Virginia, near Richmond; James Perronneau Royall (above right), the elder half brother of Croskeys Royall and a graduate of South Carolina Medical College in 1861, was killed on July 1, 1862, at Malvern Hill, Virginia; Rawlins Holmes Rivers (below left) was killed while acting as a courier at Chickamauga, Tennessee, on September 23, 1863; Julius Constantine Seabrook (below right) was killed on December 14, 1862, at Fredericksburg, Virginia. (Courtesy of Willis J. Keith.)

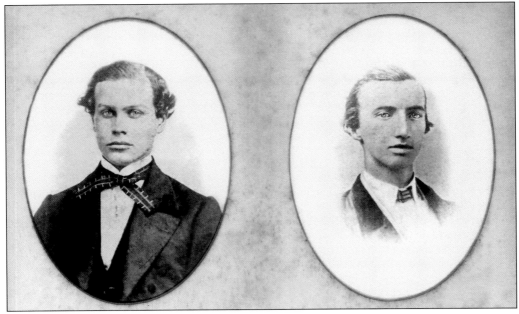

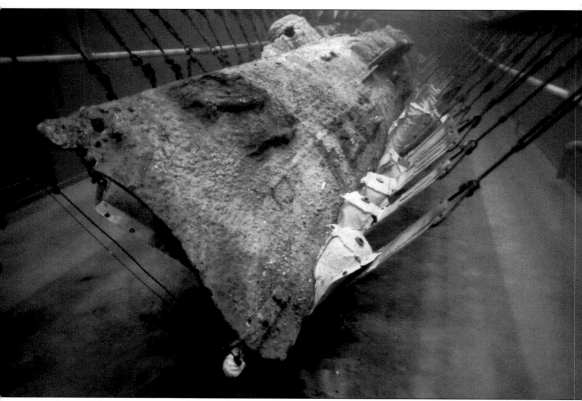

Discovered in 1995 off the coast of Sullivans Island, South Carolina, 131 years since its burial at the bottom of the sea, the *H. L. Hunley* was finally resurrected in 2000. On August 12, 1863, the Confederate submarine (later named *H. L. Hunley*) arrived in Charleston from Mobile, Alabama, in hopes that the innovative vessel might relieve the Federal blockade on Charleston Harbor. Desperate for a Confederate naval victory, General Beauregard ordered the submarine's first mission on the night of August 29, which ended in disaster—the drowning of five crew members—in the water just off of James Island's Fort Johnson wharf. Convinced that this first fatal sinking was the result of an inexperienced crew, Horace Hunley, the submarine's financier and namesake, arranged to furnish the submarine with a crew from Mobile that was knowledgeable with its operations. Thus, the secret submarine was raised and prepared for its next mission. The second attempt, on October 15, 1863, similarly succumbed to disaster when the submarine sunk on a routine diving exercise, claiming the lives of all eight crew members. Horace Hunley, serving as captain, was among the eight drowned in this second mortal mission. Raised again, on the night of February 17, 1864, just outside of Charleston Harbor, the *Hunley* embarked on its third, and final, mission. Stealthily approaching the Federal sloop of war *Housatonic*, the Confederate submarine planted a torpedo in the ship's side. The attack sank the *Housatonic* in three minutes and took the lives of five of its crew, making the *Hunley* the first submarine to engage and sink an enemy warship. Moments after completing its successful mission, though, the victorious submarine and the eight crew members inside disappeared into the sea. Pictured in 2002, after its raising, is the historic *H. L. Hunley* submarine in its conservation tank at the Warren Lasch Conservation Center in Charleston. (Courtesy of Friends of the Hunley.)

John Stolle's 1896 oil painting of William Godber Hinson (1838–1919) shows the James Island planter in his Confederate cavalry uniform. Upon the outbreak of the War between the States in 1861, Hinson joined Capt. William Trenholm's company, the Rutledge Mounted Riflemen and Horse Artillery, serving along the Carolina coast until he was ordered to Virginia in 1864—at which time his previous battalion merged to form the 7th South Carolina Cavalry Regiment under Col. Alexander Cheves Haskell. He served with this regiment until the surrender of General Lee at Appomattox Court House on April 9, 1865. He was wounded three times during his service and was almost killed when his horse was shot and fell on him. (Courtesy of Lavinia Mikell Thaxton.)

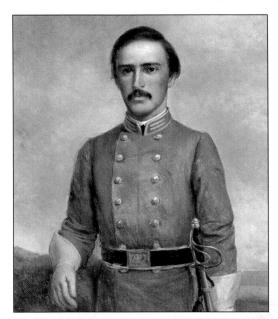

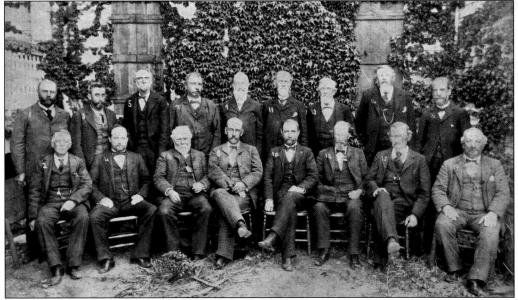

On April 24 and 25, 1895, at the Stiles Point Plantation home of William Godber Hinson, the Confederate veterans of James Island reunited, recalling moments from their boyhood, reflecting upon the changes since the war, and remembering their comrades who gave their lives in the war. With a bottle of Madeira that Hinson's father purchased in 1835, and which he had saved by burying when General Sherman passed through the state in 1865, they drank to the memories of those who were not present. Pictured from left to right are (seated) J. M. Holmes, W. A. Clark, J. T. Dill, E. T. Legare, William Godber Hinson, Dr. Robert Lebby, Constant H. Rivers, and Charles H. Rivers; (standing) S. L. Hinson, J. F. Lawton, Elias Lynch Rivers, William B. Seabrook, Dr. B. M. Lebby, W. B. Minott, R. E. Mellichamp, and J. H. Freer, Robert Bee. (Courtesy of Lavinia Mikell Thaxton.)

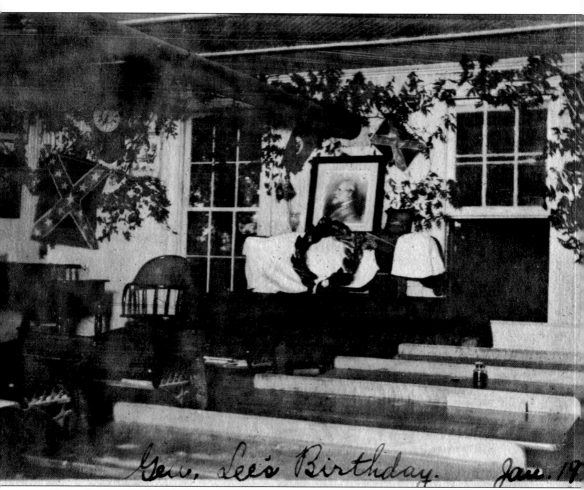

Gen. Lee's Birthday. Jan. 19

Forty-five years after the conclusion of the War between the States, Gen. Robert E. Lee was still heralded as a hero by James Islanders, as demonstrated in the above 1910 photograph of the general's birthday commemoration, which was held at the James Island United Daughters of the Confederacy. (Courtesy of Anna Lebby Campbell.)

Three

LIVING OFF THE LAND

Beginning in the earliest days on James Island, cultivation of the land has been paramount to the survival of this once-tiny community. From the lucrative days of commerce when Sea Island cotton begot fortunes for Southern planters, to the tumultuous destruction and aftermath of the War between the States when shifting social and economic structures altered the plantation system, James Islanders have always relied upon the land for stability and sustenance.

While the saltwater around James Island has provided a playground for residents and sea-life for nourishment, the rich earth has fed residents in the form of daily meals, as well as through commerce. Throughout James Island's agrarian history, a variety of produce—asparagus, beans, cabbage, corn, cucumbers, melons, potatoes, and tomatoes—has been grown in the fertile island soil.

After the War between the States, James Island was in a state of economic collapse with only six plantation homes surviving the battles that ravaged the land. The management of labor was of foremost concern after Emancipation, prompting the James Island Agricultural Society to be organized.

Upon the demise of Sea Island cotton in the 1920s, truck farming was adopted, but as the value fluctuated with agrarian produce, several farmers began adding dairy herds. The sale of milk added a steady cash flow to the seasonal and variable earnings of crops. As the dairy industry grew, high-protein foods such as sweet potatoes, corn, and velvet bean hay became a priority to feed the cows in order to produce more milk. However by the mid-20th century, successful planters and farmers were forced to move their businesses to neighboring Johns Island as development enveloped James Island.

With the relocation of these traditional farms, James Island's agrarian identity began to disappear. As development has increased, property taxes have driven most farmers out of the area in exchange for subdivisions and condominiums. Today, however, many local residents retain the James Island tradition of living off of the land by utilizing the historically fertile soil to grow gardens and produce in their backyards.

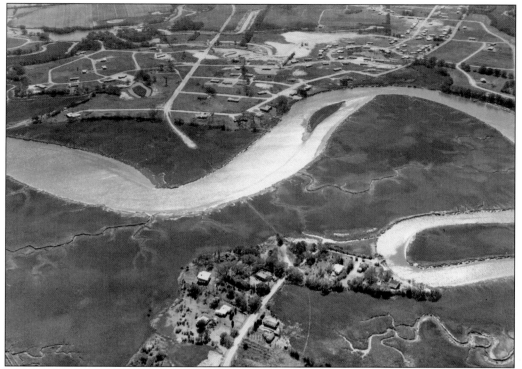

This c. 1954 aerial photograph reveals James Island Creek at high tide before Harbor View Road was connected by a bridge (now the Dr. Julian Thomas Buxton Jr. Bridge) in 1964. Development had begun, though the island was still very rural. "Harbor View," the family home of James and Annie McLeod Frampton on Summer House Island, bordering the McLeod Plantation property, faced left toward the harbor and is visible at the bottom of the photograph. (Courtesy of the *Post and Courier*.)

This 1999 photograph of Grimball Farms along the Stono River shows the fertile farmland of James Island. At this time, the Grimball property was one of the largest remaining undeveloped tracts on the island. (Courtesy of Frances Robinson Frampton.)

34

Originating in the West Indies and brought to South Carolina in 1786 from the Bahamian Islands, Sea Island cotton yielded a long, fine, silky fiber, rendering it exceedingly valuable in American and English markets. Planters on James Island and along the South Carolina and Georgia coasts prospered for many years raising Sea Island cotton. Land on the Sea Islands of South Carolina became the state's most valued because of the success of and demand for this commercial crop. The first cotton mill in South Carolina—arguably the first cotton mill in America—was established on James Island in 1789 by Frances Ramage, a planter's widow. (Courtesy of Dorothy Ellen Royall Ariail.)

This 1862 print from *Frank Leslie's Illustrated Newspaper* depicts the steps of cotton cultivation and preparation: hoeing, planting, picking, whipping, moting, ginning by steam, ginning by foot, packing, and shipping. (Courtesy of the Library of Congress.)

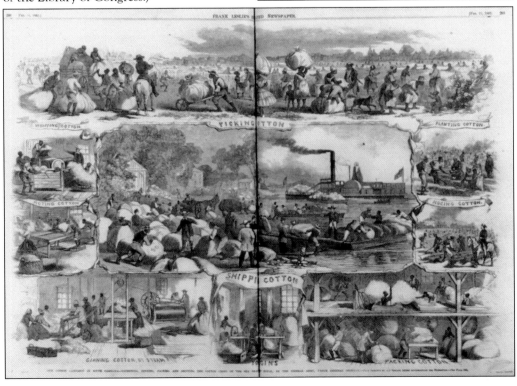

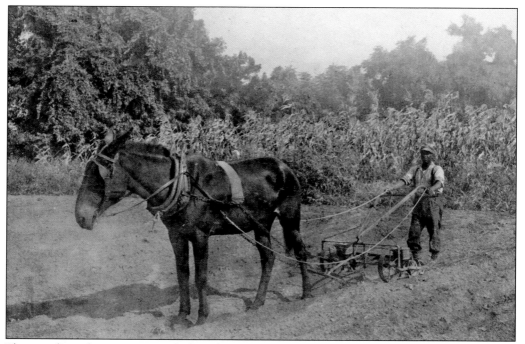

Plowing the soil was important before planting to turn over the upper layer of soil, to loosen the soil for easier planting, and to reduce the prevalence of weeds in the fields. The horse-drawn plow seen here was used by many even after the introduction of tractors and other modern machinery. Sea Island cotton fields were rarely plowed before the war, however, as hoeing was the predominant method. (Courtesy of Lavinia Mikell Thaxton.)

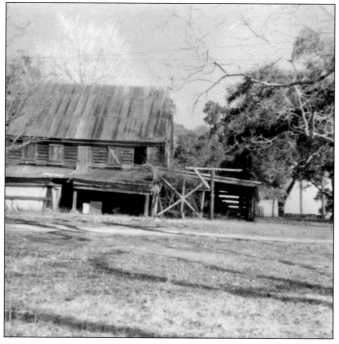

During the reign of Sea Island cotton, the cotton gin house, which contained the equipment used for separating the cotton fibers from the seeds, was a vital fixture on James Island plantations. Following the demise of cotton production on the island in the 1920s, most plantation gin houses were employed as tool sheds and for storage. Pictured above is the Stiles Point Plantation gin house, the loft of which still contained cotton in the 1940s and 1950s. Another function of some gin houses after the 1920s was to accommodate dance parties for James Islanders during their youth. (Courtesy of John Jerdone Mikell.)

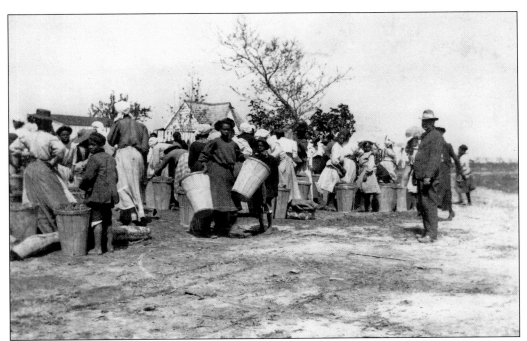

Henry Bailey Grimball (right) oversees the packing of cotton at the packing shed by his farm hands on Grimball Plantation around 1920. After cotton, tomatoes, soybeans, and other truck crops were planted in this fertile land along the Stono River. (Courtesy of Frances Robinson Frampton.)

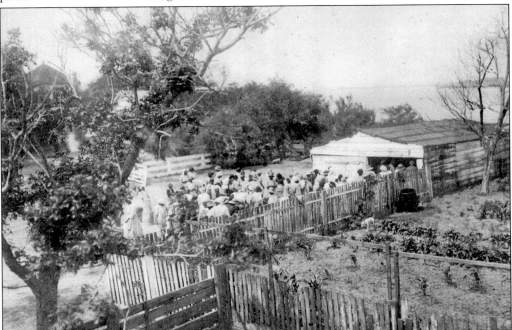

In this c. 1920 photograph, farm hands weigh the cotton they have just picked at the cotton shed on Grimball Plantation along the bank of the Stono River, which is visible in the distance. Cotton pickers were paid by the pounds of cotton picked. (Courtesy of Frances Robinson Frampton.)

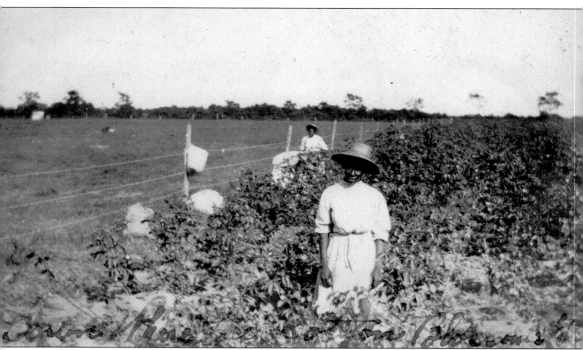

After 1870, the agricultural system on James Island had progressed from the group contract system to tenant farming, a system in which landowners rent a portion of their land to be lived on and worked by a tenant. Tenant farming offered African Americans more freedom to farm the land without intervention from the white planters and a greater possibility of accruing enough money to eventually buy land of their own to farm. Pictured around 1920, James Islander Lizzie Washington picks cotton. (Courtesy of Anna Lebby Campbell.)

In response to changes in labor policies following the War between the States and in an attempt to control the new economic and social order on the island, on July 4, 1872, a small group of white James Island planters met at the home of William Godber Hinson on Stiles Point Plantation to establish the James Island Agricultural Society. As tenant farming was now the established system on the island, the foremost objective of the organization was to discourage wage competition between the planters and to set rules by which labor would be managed. Early on, a tradition of "riding the crops" was adopted, in which members surveyed the lands of their fellow planters on horseback, sharing advice and offering suggestions to improve the overall quality of agriculture on the island. Initially, the James Island Agricultural Society held meetings in the homes of its members, and later, meetings were held at the armory of the Haskell Mounted Rifles at the northwest corner of Fort Johnson Road and Dills Bluff Road. Shown in this c. 1930 photograph is the entrance to the South Carolina Agricultural Society grounds at the intersection of Camp and Fort Johnson Roads. (Courtesy of the South Carolina Historical Society.)

The advent of the boll weevil, a beetle which feeds upon cotton buds, in 1917 devastated cotton cultivation and brought about the demise of the crop on James Island within a few years of its arrival. Thus, in the early 1920s, James Island plantations shifted to truck farming with the cultivation of vegetable crops for market. On James Island, truck crops included Irish potatoes, cucumbers, cabbage, beans, tomatoes, and sweet potatoes. Pictured above, potatoes at Stiles Point Plantation are being dug and bagged. Afterward they were transported to the "potato washer" (shown below), a building equipped with conveyor belts and sprayers, and manned by workers who graded the potatoes by hand. (Above, courtesy of John Jerdone Mikell; below, courtesy of Lavinia Mikell Thaxton.)

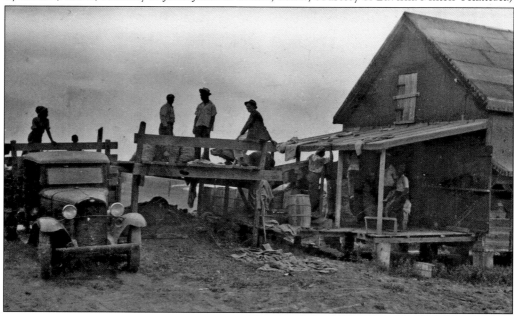

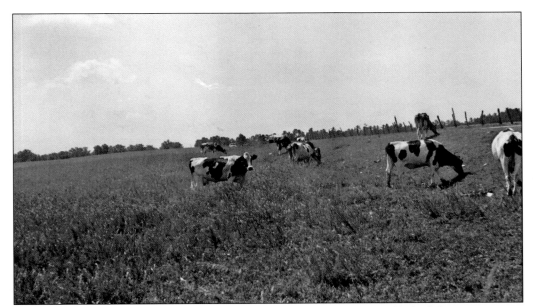

In addition to truck farming, many James Island plantations also established dairy operations in the 1920s. This was an attempt to offset the financial losses brought about by the failure of cotton crops and the shortage of labor due to a continuing migration of black islanders from the rural Sea Islands northward in search of better wages. Pictured in the early 1940s is an old cotton field at Stiles Point Plantation that served as pasture land for dairy cows. (Courtesy of Lavinia Mikell Thaxton.)

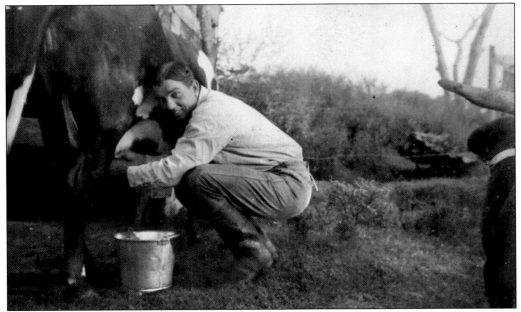

Ephriam Clark Seabrook is pictured milking his cow. His love of nature and the environment was passed on to his neighbors and students. "Ephie" was an inspiring football and basketball coach and teacher at Charleston High School. In addition, he organized activities for the youth of James Island. (Courtesy of Mary Seabrook Oswald Godbold.)

W. Gresham Meggett (right) begins the agrarian education of his son W. Gresham Meggett Jr. by teaching him to milk Jansie, the family cow. (Courtesy of Gresham and Carole Meggett.)

Sisters Dorothy "Bunny" Agnes Mikell (above) and Frances "Cukes" Dill Mikell (below) pose behind their house at Stiles Point Plantation. In the background is the wharf and the large asparagus house where plantation produce—asparagus, potatoes, cabbage, and cucumbers—was stored until it was transported by boat from the wharf to the docks of Charleston to be sold or to be shipped North. (Courtesy of Frances Mikell Tupper.)

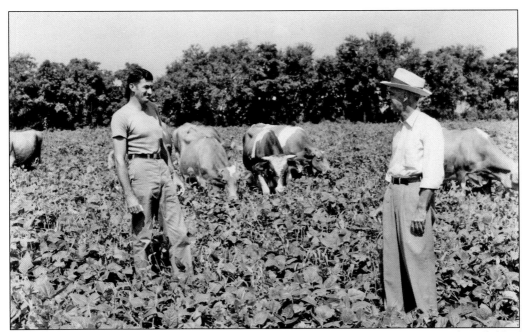

Benjamin Stiles Mikell (left) and William Hinson Mikell, father and son, survey their field of cowpeas—planted for summer grazing—which will be turned under for the fall planting of truck crops at Stiles Point Plantation. (Courtesy of Lavinia Mikell Thaxton.)

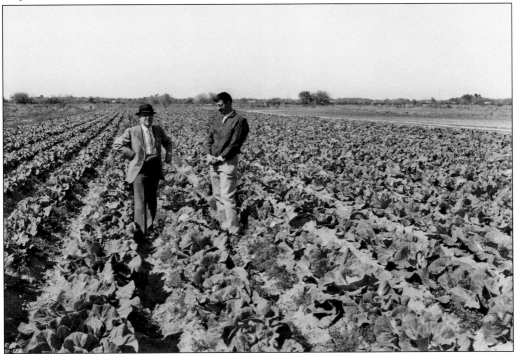

Supervisor T. Wilbur Thornhill (left) and William H. Mikell observe an excellent crop of cabbage after improving field drainage at Stono Plantation in 1962. (Courtesy of Lavinia Mikell Thaxton.)

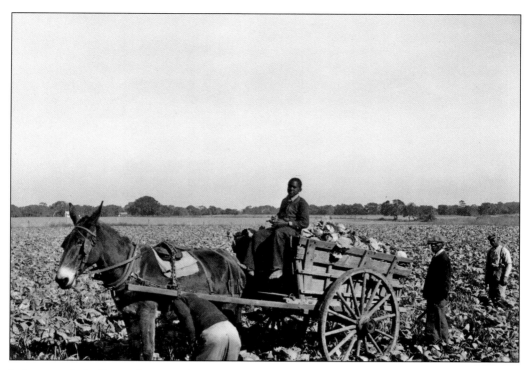

Laborers at Stiles Point Plantation harvest cabbage (above) and pack it (below) for the market in the early 1940s during James Island's truck farming years. (Courtesy of Lavinia Mikell Thaxton.)

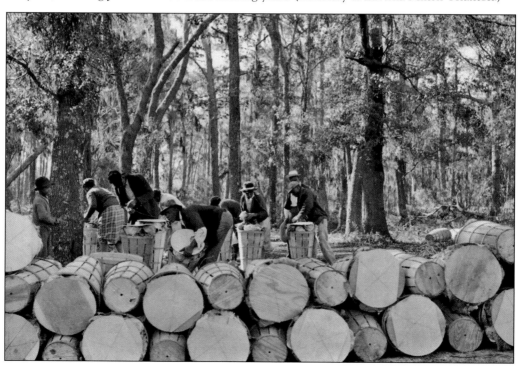

In the tradition of his father and grandfather before him, a young James Perroneau Royall practices the annual custom of "riding the crops" on horse in this c. 1915 photograph. Behind him are the experimental fields of cotton on the grounds of the South Carolina Agricultural Society. (Courtesy of Dorothy Ellen Royall Ariail.)

The young Royalls enjoy James Island's rustic landscape in 1914. On Cornish Farms, which later became part of Baview Farms, pictured from left to right are Robert Oswald Jr., Annie O'Neill Royall, Katherine Louise Royall, and James Perronneau Royall. (Courtesy of Anna Lebby Campbell.)

This 1954 photograph depicts three playmates standing next to chinaberry trees along James Island Creek. During this time before James Island was developed, the land was a rural and safe wonderland of dirt roads, wide open fields, and shallow creeks for childhood adventures. (Courtesy of Amelia E. Jenkins.)

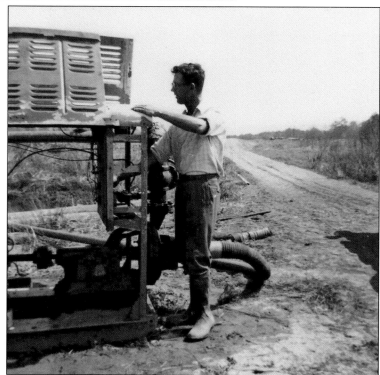

Hinson Lebby Mikell checks the operation of the field irrigation system at the pump site at Stiles Point. (Courtesy of John Jerdone Mikell.)

Bunny Brown operates his horse-drawn "poison machine," which was used to treat crop disease. (Courtesy of John Jerdone Mikell.)

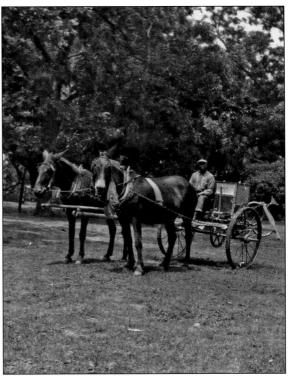

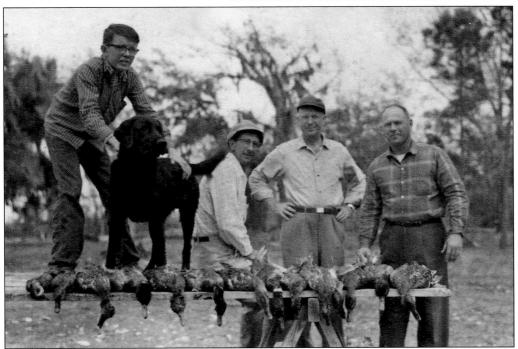

William Hinson Mikell (seated) and his friends pose for a picture after their successful duck hunt. (Courtesy of Lavinia Mikell Thaxton.)

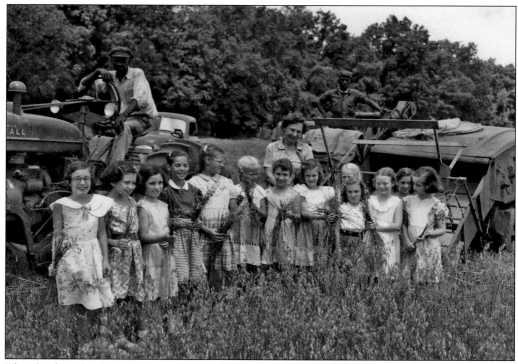

The third grade class of Ashley Hall and their teacher, Sue Achurch, pose for a picture during their field trip to Stiles Point Plantation in 1953. The Campbell brothers are seated on the tractors. (Courtesy of Lavinia Mikell Thaxton.)

Cousins Frannie Tupper (left) and Dottie Fishburne learn to drive their grandfather Park Mikell's tractor at Stono Plantation. (Courtesy of Frances Mikell Tupper.)

Joe Campbell and his friends take a break to pose for a picture beside their Massey-Ferguson tractor. (Courtesy of John Jerdone Mikell.)

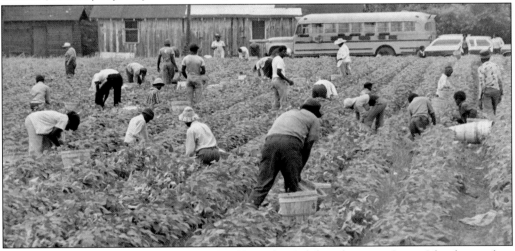

This photograph of snap-bean pickers at land leased to Sidi Limehouse on James Island was taken in the final years of Limehouse's fields on the island. Limehouse, like many others who once farmed on James Island, was forced to move to neighboring Johns Island where land was more readily available and not so easily encroached upon by real estate developers. Following the trend on James Island, though, the rural nature of Johns Island is rapidly disappearing as farmland is developed, putting a small local business like Limehouse's Rosebank Farms at risk for extinction. (Courtesy of the *Post and Courier*.)

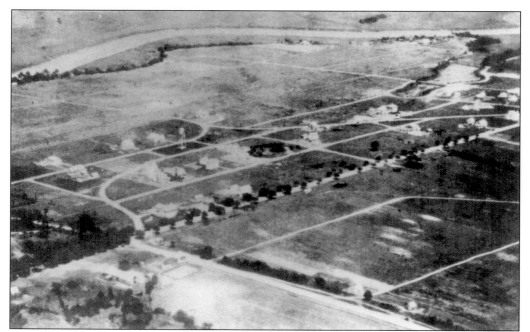

Some island landowners turned to real estate development, dividing their holdings into residential subdivisions. The first such development on James Island was Riverland Terrace, which was laid out in the 1920s and developed in the 1940s, making it James Island's oldest neighborhood. This 1933 aerial photograph of Riverland Terrace shows the neighborhood's famous Avenue of Oaks and the Stono River. (Courtesy of Tom and Anne Read.)

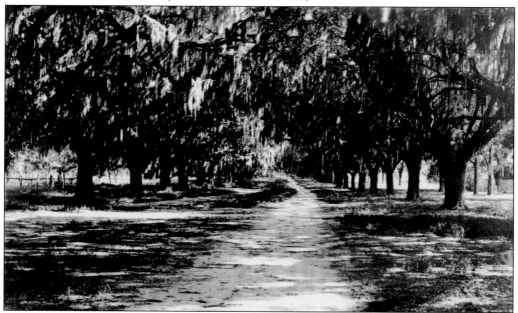

Riverland Terrace's historic Avenue of Oaks, consisting of 73 live oak trees planted by Priestley C. Coker, once led to James Island's Wappoo Hall Plantation on the Stono River. Today these trees line the neighborhood's Wappoo Road. (Courtesy of Anna Lebby Campbell.)

The suburban development of the 1950s and 1960s changed a simple island of scenic waterways and lush farmlands to one of subdivisions and automobile congestion. (Courtesy of the *Post and Courier*.)

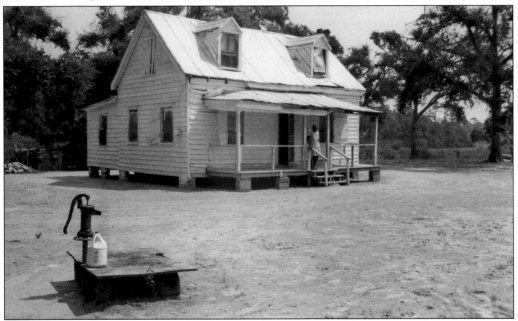

Eleanor Washington stands on the porch of her simple James Island house in this 1990 photograph. Her frame home, situated off an old dirt road and with its hand-pumped well, reminds passersby of the James Island of an earlier era. (Courtesy of the *Post and Courier*.)

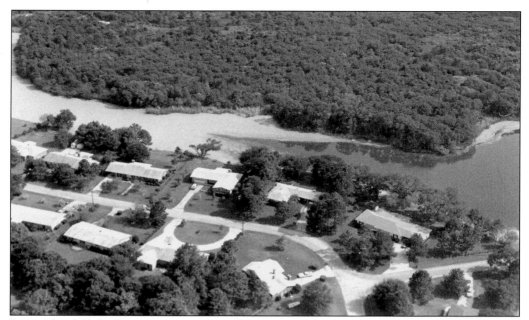

James Island's Lake Frances area was part of the Lawton Plantation property purchased as a truck farm in the early 1950s by Frank P. Whitehurst from John R. Jefferies, who had purchased the plantation from Alison and Ruth Lawton in 1946. Named by Whitehurst for his wife, Lake Frances was part of a salt water slough in 160 acres of marsh that had been dammed for nearly a century. The water was used for crops and cattle. As development progressed, it became a retention pond for street and property runoff. (Courtesy of Tom and Anne Read.)

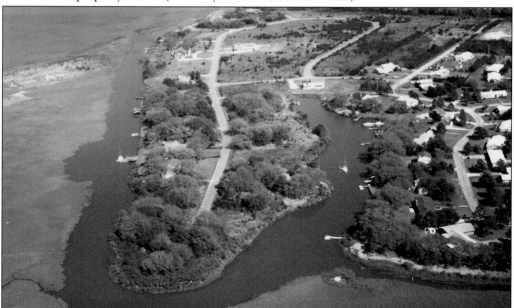

Located north of Lake Frances, James Island's White Point Estates neighborhood was so named because it overlooked the Charleston Battery and White Point Gardens. (Courtesy of Tom and Anne Read.)

Four

PLANTATIONS

From the late 1600s until the end of the War between the States in 1865, James Island was a plantation society based on slavery. However, majority of the first planters in the 1700s did not reside on the island. They retained homes in Charleston, and their properties on James Island were solely for planting. In the 1800s, though, more planters began to plant and live on James Island. Prior to the War between the States, approximately 21 white planters and their families called James Island home. Among those families owning plantations on the island before or immediately following the war were Bee, Clark, Dill, Ellis, Grimball, Hinson, Lawton, Lebby, Legare, McLeod, Mellichamp, Mikell, Rivers, Royall, and Seabrook. While some of the island's plantations were named after the families who owned them, other plantations acquired names based on the characteristics of the land they encompassed, for example, Centerville, Lawton Bluff, Lighthouse Point, Oceanview, Seaside, Secessionville, Stono, Stiles Point, and Wappoo Hall.

Though the plantation complex at McLeod Plantation is the only one surviving on the island from the antebellum era, several of the original antebellum and postbellum plantation houses have survived; among them the Stiles-Hinson House (Stiles Point Plantation), the Heyward-Cuthbert House (Lawton Bluff Plantation), the McLeod Plantation House, the Seaside Plantation House, the Secessionville Manor House, the Seabrook-Freer House, the Ephriam Mikell Clark House (Oceanview Plantation), and the Stono Plantation House. Preceding the war, the plantation economy of James Island required a large slave-labor force. Following the war, many plantation families and freedmen returned to the island to rebuild their homes, lives, and the island's war-ravaged economy. Without slave labor, plantations were forced to rely on the system of tenant farming to sustain the island's economy, and gradually, former slaves and their descendants began to acquire land of their own to farm.

In his recent James Island book, Eugene Frazier Sr. focuses solely on tracing the surviving names and stories of the island's slaves and their descendants. Prominent names such as Bright, Champaign, Fleming, Gladden, Goss, Green, Lafayette, Lemon, Prioleau, Richardson, Simmons, Smalls, Washington, White, and Wilder—to name a few—still exist in the James Island community. And today descendants of both the first planters and the Africans who were enslaved in this agrarian plantation system are intermingled harmoniously in James Island's social fabric.

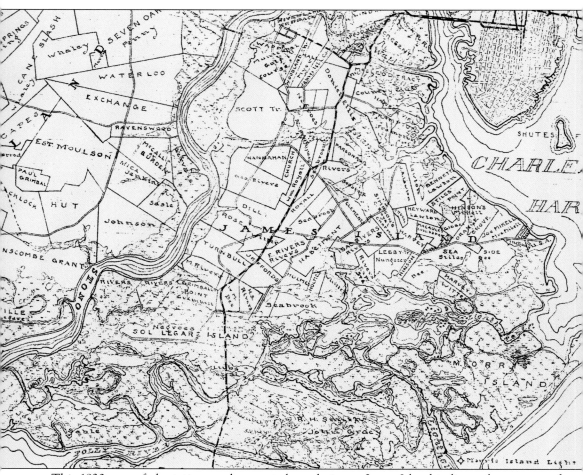

This 1930 map of plantations and property boundaries on James Island indicates large tracts of land still being owned by a small number of families, some of them descended from the island's first planters. Without the slave labor foundation of the plantation system, the postwar way of life, by many accounts, was more tranquil and purposeful than the overdeveloped, commercial pace of James Island today. Plantation lands were vast in terms of what is available for farming on the island now, and the many components of the plantation systems were coordinated to provide for the residents, as well as to transport the produce to boats leaving the plantation docks. (Courtesy of Tom and Anne Read.)

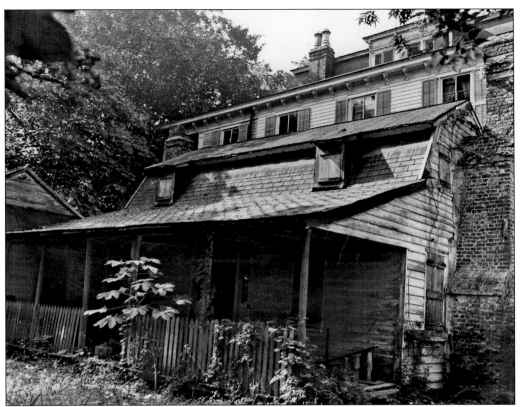

The Stiles-Hinson House is the oldest remaining plantation house on James Island, dating back to 1742 when Benjamin Stiles erected the original 1-and-1/2-story colonial farmhouse (above) facing the harbor. In 1891, a large 2-and-1/2-story Victorian house (below) was built adjacent to the 1742 structure by William Godber Hinson. (Above, courtesy of Lavinia Mikell Thaxton; below, courtesy of Edward LaRoche Grimball.)

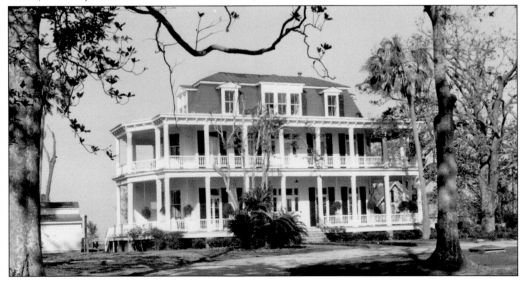

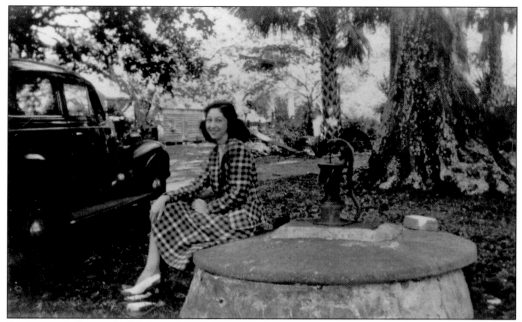

Pauline Mikell Grimball sits on the old stone well at Stiles Point Plantation in May 1940. (Courtesy of John Jerdone Mikell.)

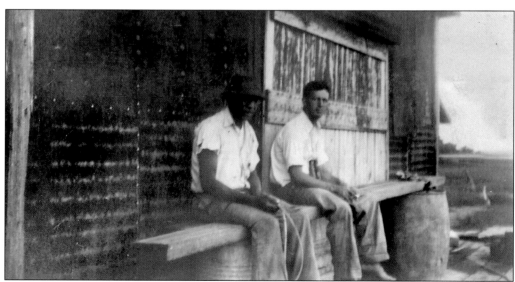

Pictured in 1940, Sam Williams (left) and Hinson Lebby Mikell relax at the Stiles Point Plantation boathouse. (Courtesy of Pauline Mikell Grimball.)

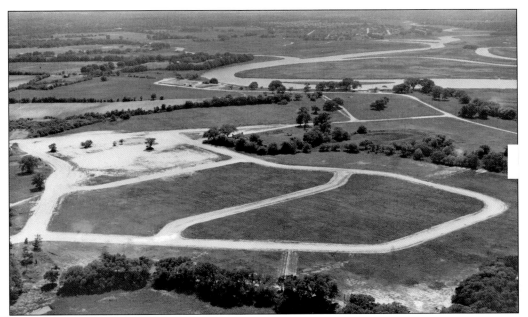

By the mid-1920s, Lawton Plantation had become the largest dairy in the Charleston area. This aerial view of the Lawton Plantation land shows the Cuthbert House in the center and James Island Creek in the upper right. (Courtesy of the *Post and Courier*.)

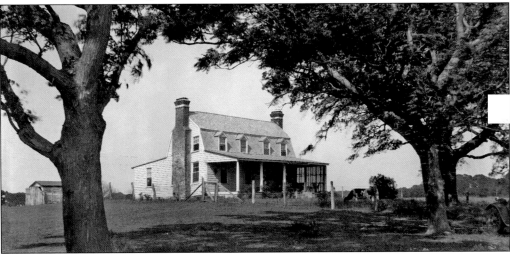

Erected by Thomas Heyward Sr., father of a signer of the Declaration of Independence, the Heyward-Cuthbert House, built in 1747, still maintains the façade of a simple colonial farmhouse of the early 1700s. It became part of the Lawton Plantation in 1813 when Winfield Lawton acquired it, and it was used during the War between the States as a hospital for African American victims of smallpox. Following the war, when Wallace and Cecilia Lawton returned to James Island to find their home destroyed, they moved into this house, which was restored around 1871. Fifty years later, when Clyde Bresee's family moved from Pennsylvania to manage dairy operations for Alison Lawton, the Bresee family moved into this historic house. This c. 1930 photograph depicts the house on Lawton Plantation while the plantation was still operating primarily as a dairy. (Courtesy of the South Carolina Historical Society.)

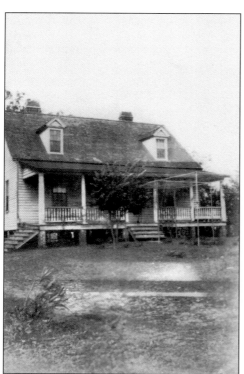

Pictured around 1923 is the house located next to James Island Creek and built for St. John Alison Lawton and his wife, Ruth, the owners of Lawton Plantation. (Courtesy of Clyde Bresee.)

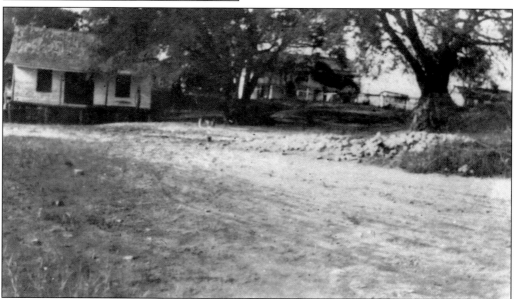

This photograph, taken between 1910 and 1920, shows the road along James Island Creek leading to the Lawton store gin house and residence belonging to St. John Alison and Ruth Lawton. The plantation store (left) was a place for social gatherings on the Lawton Plantation, especially on Friday afternoons when it also served as a "payoff office" for the plantation's employees. Today this area is North Shore Drive. (Courtesy of Clyde Bresee.)

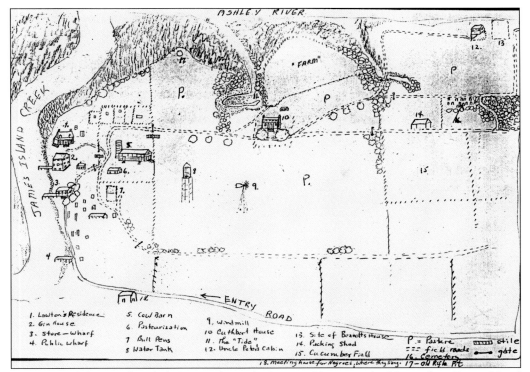

ASHLEY RIVER

JAMES ISLAND CREEK

"FARM"

P.

P.

P.

P.

P.

← ENTRY ROAD

1. Lawton's Residence
2. Gin House
3. Store — Wharf
4. Public Wharf
5. Cow Barn
6. Pasteurization
7. Bull Pens
8. Water Tank
9. Windmill
10. Cuthbert House
11. The "Tide"
12. Uncle Pete's Cabin
13. Site of Beanetts House
14. Packing Shed
15. Cucumber Field
16. Cemetery
17. Old Rifle Pit
18. Meeting house for Negroes, where they sang.

P. = Pasture — stile — field roads — gate

This original drawing by Clyde Bresee shows the Lawton Plantation buildings along James Island Creek. These buildings were the necessary outbuildings of all plantations. (Courtesy of Tom and Ann Read.)

In 1954, Dr. Louie Jenkins stands beneath a chinaberry tree on land that he and his wife, Dr. Margaret Q. Jenkins, recently purchased to build a home. Approaching by automobile are his mother and mother-in-law, who will be viewing the future sight of the Jenkins' family home for the first time. This dirt road along James Island Creek was all that remained of the old Lawton Plantation road. All of the land that once belonged to the Lawton Plantation has been subdivided. (Courtesy of Amelia E. Jenkins.)

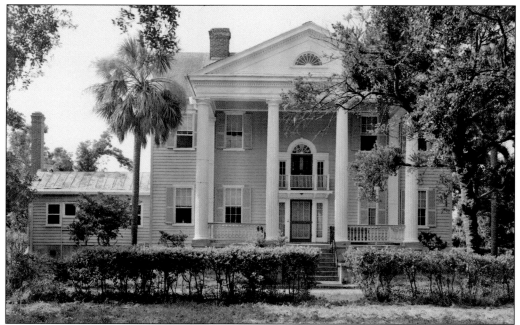

The area now known as McLeod Plantation is first detailed on a 1695 map, which shows the Morris and Rivers families as two of the landowners on this property. Built by William McLeod around 1858, this dwelling was used as Confederate army unit headquarters during the War between the States and was also briefly used as a hospital. From 1865 to 1867, it served as the headquarters for the Freedmans Bureau on James Island. A simple country house, it was altered to become a fine example of Greek Revival architecture in the early 1900s. Today McLeod Plantation is the only antebellum plantation complex on James Island that has remained essentially intact. (Courtesy of the Library of Congress.)

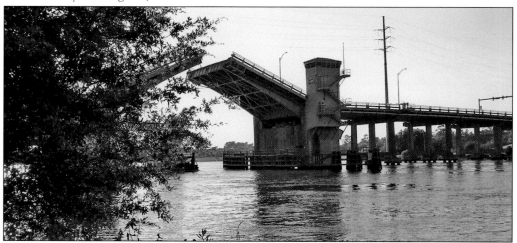

This view of the current Maybank Bridge over Wappoo Creek was taken in 2003 from the landing at McLeod Plantation where crops were loaded and transported by water to markets in Charleston. The McLeod Plantation store, one of James Island's many plantation stores that served plantation workers and other island residents, was located on the eastern side of the landing. (Courtesy of Friends of McLeod.)

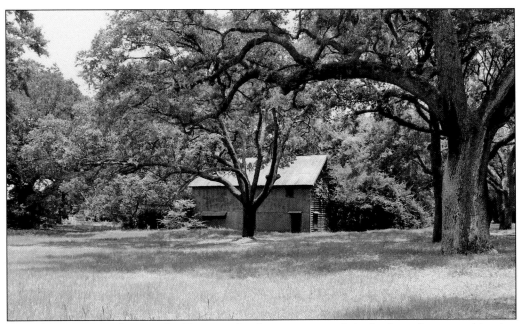

One of the most significant outbuildings on the plantation grounds in the days of cotton cultivation was the gin house. The eastern half of the cotton gin house at McLeod Plantation (pictured above) dates to the 19th century, at which time Sea Island cotton was in its prime on James Island. This gin house still stands on the McLeod Plantation property today, although the cotton gin itself is no longer at the plantation. Although this photograph is modern (2003), it aptly indicates the degree to which history has survived at McLeod Plantation. (Courtesy of Friends of McLeod.)

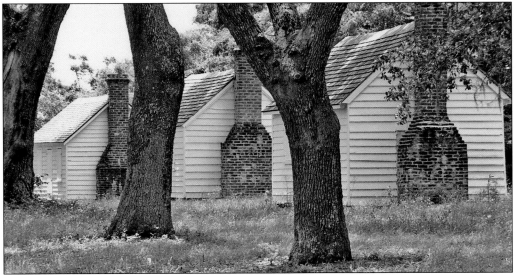

Many of the original slave cabins built in the late 18th century, when the property now known as McLeod Plantation was owned by the Lightwood and Parker families, remain on the plantation today. Until 1990, tenant farmers and African Americans who worked on the plantation continued to live on the plantation grounds, renting the former slave cabins from William Ellis McLeod. (Courtesy of Friends of McLeod.)

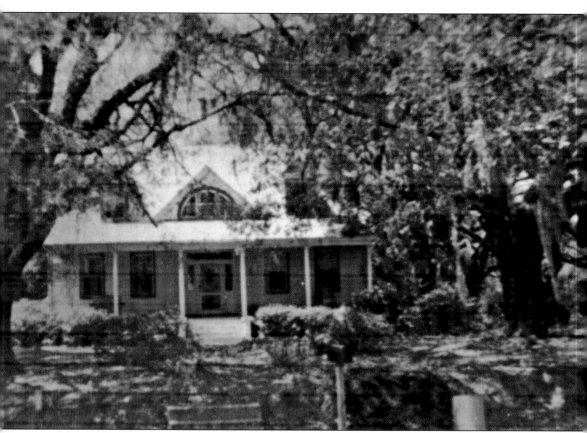

Built around 1840 by Croskeys Royall, this house served as the headquarters for numerous Confederate generals during the War between the States after the Royall family evacuated inland. On November 3, 1863, when Pres. Jefferson Davis of the Confederate States of America was inspecting local fortifications on James Island, General Hagood brought him to dine here while he was occupying the house as his headquarters. Acquiring the house in the early 1900s, William Godber Hinson of Stiles Point Plantation incorporated elements of the original Royall house into a new construction and presented it as a wedding gift for W. H. Mikell and Cecile Lebby Mikell in 1909. Upon his death in 1919, Hinson left his Stiles Point house to the Mikells, and his nephew Julian Hinson Clark was given this house, which remained in the Clark family until it was destroyed by fire in 1979. (Courtesy of Mary Clark.)

Built in 1852 by William B. Seabrook—a state representative from 1852 to 1855—as his residence in the summer village of Secessionville, the Seabrook-Freer House is so named because Seabrook, shortly after completing it, sold it to Edward Freer, a prominent James Island planter. Seabrook then moved into the neighboring Secessionville Manor. From 1873 to 1918, the Seabrook-Freer House served as the James Island Presbyterian Manse. (Courtesy of Mary Oswald Godbold Davis.)

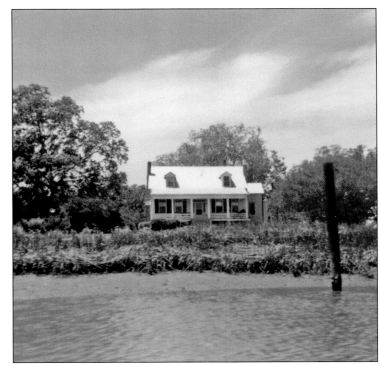

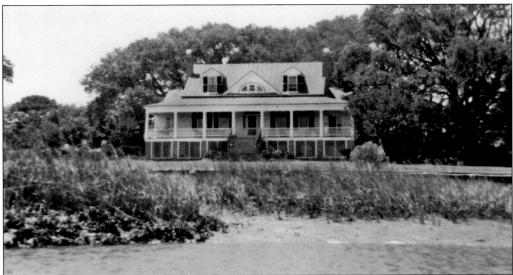

Built for William B. Seabrook in 1858 as his Secessionville Plantation home in the summer village of the same name, Secessionville Manor served as the Confederate headquarters of the Eutaw Battalion (later the 25th Regiment) under Lt. Col. Simonton, which participated in the defense of nearby Fort Lamar. This house and the Edward-Freer House next door were the only two houses from the summer village of Secessionville to survive the War between the States. This 1985 photograph shows the plantation house much as it would have appeared 150 years ago, although the porch and center dormer are probably postwar additions. (Courtesy of Mary Oswald Godbold Davis.)

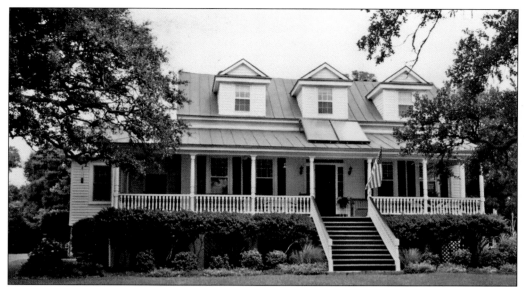

Located on the southern shore of James Island, just yards from James Island's Clark Sound, the Ephriam Mikell Clark House—Oceanview Plantation—was built in 1867. The west wing postdates the 1867 construction. It was most likely the first major residential construction on James Island following the War between the States and was briefly used as a gathering place for Presbyterian worship after the war. The house is now owned by William and Mary Davis, a granddaughter of Cecil and Jennie Oswald. (Courtesy of Mary Oswald Godbold Davis.)

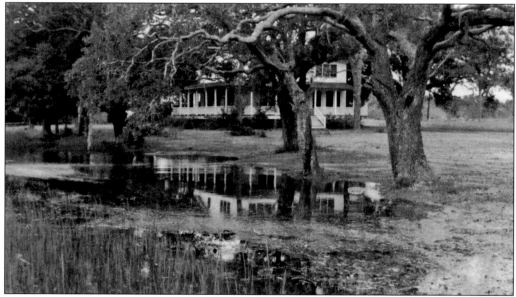

As early as the mid 1700s, members of the Dill family began planting on the land now known as Stono Plantation. Positioned along the Stono River, the Stono Plantation house (pictured above) was owned by the three Dill sisters—Julia, Pauline, and Frances—and was built around 1915. During the modern era, the plantation was managed by Fuller King and his family, followed by Park Mikell, who oversaw the plantation until the 1960s. This house and surrounding property are currently owned by the Charleston Museum. (Courtesy of Frances Mikell Tupper.)

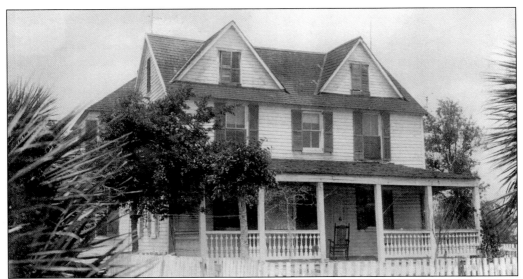

Grimball Plantation, located along the Stono River on the west side of James Island, is bordered by the Dill Plantation to the north and Sol Legare Plantation to the south. On June 2, 1862, Federal forces landed on the James Island plantation of Thomas H. Grimball along the Stono River on the west side of the island. The second skirmish between Confederate and Federal forces on the island occurred on June 10, 1862, at this site on Grimball Plantation. The first skirmish was at neighboring Sol Legare Island on June 3. The Grimball home (pictured above) was constructed following the War between the States. (Courtesy of Frances Robinson Frampton.)

Ellis Plantation along James Island Creek was owned by Dr. Daniel Ellis, whose family moved to James Island following the war. The original Ellis Plantation house was demolished. The Ellis house above was built by Daniel Ellis Jr. and moved across Folly Road in the 1990s to the property of the Welch family, cousins of the Ellis family. When the family sold the land in 1990, their house was moved across Folly Road to its current location. (Courtesy of Daniel Wordsworth Ellis IV.)

The Seaside Plantation House on Clark Sound, photographed in 2007, was built in the early 20th century and was owned by the Bee family. The land surrounding this plantation house, which is today developed, was primarily used for tomato farming. (Courtesy of Anna Pruitt.)

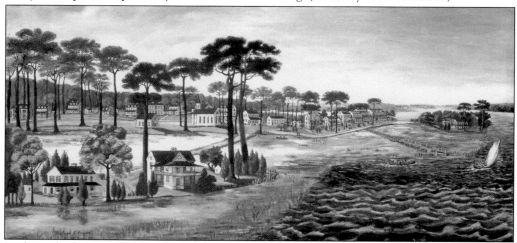

In the early 19th century, Lowcountry planters began moving their families from the plantations to summer villages from mid-May to mid-October to avoid malaria and yellow fever. On James Island, planters either retreated to Johnsonville—the more popular summer village for planters—located at Fort Johnson on the eastern tip of James Island or to Secessionville. Originally named Riversville, the summer village of Secessionville (on present-day Fort Lamar Road) along Clark Sound, may have been renamed by its inhabitants who said they were "seceding" from their peers who preferred more established retreats. Shown above is a painting of the Johns Island summer village of Legareville, which James Island's Johnsonville and Secessionville undoubtedly resembled. Situated along the Stono River directly across from James Island's Sol Legare Island, Legareville was named for the Legare family, planters with lands on both Johns and James Island. (Courtesy of the South Carolina Historical Society.)

Five

SOCIETY

James Island's earliest churches, James Island Presbyterian and St. James Episcopal, were established in the early 1700s as the first gatherings revolved around religion. These two congregations have been closely tied throughout the island's history as members from each congregation intermarried and because shared worship services were necessary for many years. Since neither church had a congregation large enough to support a full-time minister, they alternated holding services every other Sunday. Plantation slaves were included in worship, but only under supervision.

Before the War between the States, James Island Presbyterian Church had a balcony where slaves were designated to sit during the church services. St. James' Rev. Stiles Mellichamp also held afternoon services for slaves on plantations following his Sunday morning church service, since unsupervised gatherings among slaves were limited. Following the end of the war in 1865, James Island's African-Americans began to implement their new freedom by forming their own institutions, chiefly churches. The island's freedmen formed their first church in 1866 called St. James United Presbyterian Church at the corner of Secessionville Road and Fort Johnson Road. Payne R.M.U.E. (Reformed Methodist United Episcopal) Church on Camp Road and the Baptist Church of James Island, also on Camp Road, were established shortly afterward.

Schools were also early forms of organizations on the island, providing educational, cultural, and social outlets for young residents. James Island's first public school was established in 1883 as the James Island Grammar School, although evidence of a "free white school" on the corner of Dills Bluff Road and Kings Highway is documented as early as around 1860. By the late 1800s, there was one school on the island for whites and three schools for African Americans. In 1913, the fourth school for African Americans, Sol Legare School, was opened. The Riverland Terrace School became the second school for whites in 1930 until James Island High School opened in 1953 to offer the first high school degrees on the island.

Other social organizations developed after the War between the States in the forms of the James Island Agricultural Society in 1872 and the James Island Yacht Club in 1898. The Country Club of Charleston moved to James Island behind McLeod Plantation in 1925, accommodating whites. Predominantly black communities began their own social organizations, including the King Solomon Lodge on Riverland Drive and the Seashore Farmer's Lodge on Sol Legare Island.

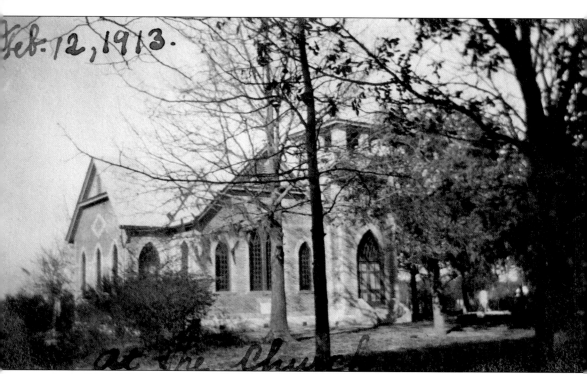

James Island Presbyterian Church was organized in 1706 by the Rev. Archibald Stobo, who also established the Johns Island and Wadmalaw Presbyterian Church. A James Island church building was erected before 1724 on land donated by Jonathan Drake. This first building was destroyed in the Revolutionary War, and the second building was destroyed by the same fire which burned St. James Episcopal Church in 1864. In 1868, construction on the third church building was completed, and in 1909, a fourth (the present) structure was built in the Gothic Revival style. This 1913 photograph shows the fourth church building shortly after it was constructed. (Courtesy of Anna Lebby Campbell.)

Anna "Arnee" Royall Lebby, the daughter of Croskeys Royall Jr. and Rosa Estelle Oswald, was born on the Royall Farm on James Island in 1884. In 1913, she married States Lee Lebby. "Arnee" was active in the church, teaching Sunday School and serving as the historian of James Island Presbyterian Church. She was one of two representatives of the Charleston Presbyterial and helped organize the "Woman's Auxiliary." (Courtesy of Anna Lebby Campbell.)

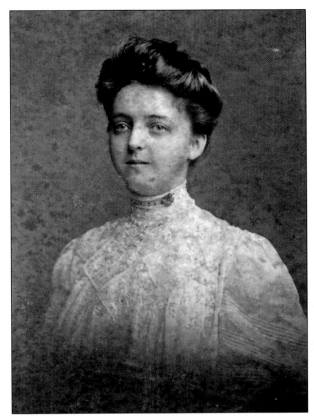

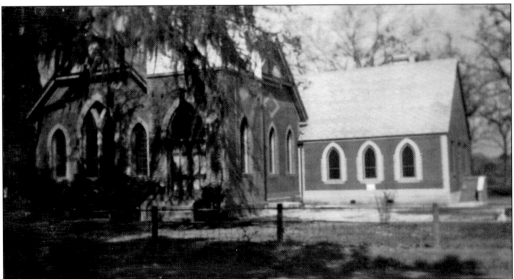

In 1939, Anna Royall Lebby donated funds to James Island Presbyterian Church for the addition of a classroom building. She asked that it be named the "States Lee Lebby Memorial Annex" in honor of her late husband, who had also been active in the church. The "Lebby Annex" is shown here in 1940. (Courtesy of Anna Lebby Campbell.)

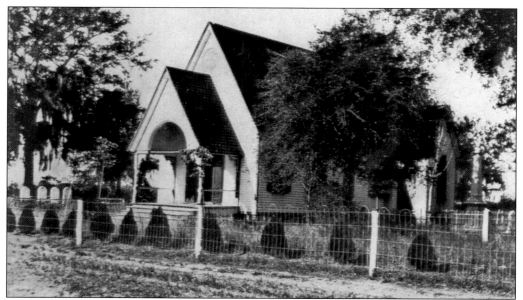

As early as 1719, Anglicans on James Island met to hear the sermons of the Rev. William Guy, who preached once a month. The first Anglican church on James Island, in St. Andrew's Parish, was built around 1730. It was destroyed by a hurricane and immediately rebuilt in 1733. It was not officially recognized as a Chapel of Ease until 1756. The 1733 chapel was destroyed during the Revolutionary War and was rebuilt shortly afterward in 1787, but it became dormant around 1800. In 1831, an Episcopal revival on the island led to the church's reorganization as St. James Church of James Island. In 1853, a new structure—the fourth—was erected in the Gothic style but was closed in 1863 due to the war. It was destroyed in 1864 by a fire. In 1899, construction on the fifth church building was completed; this structure remained until the current church on Camp Road was built in 1960. These 1956 photographs show the St. James Episcopal Church built in 1899. (Above, courtesy of Robert Welch; below, courtesy of Edward LaRoche Grimball.)

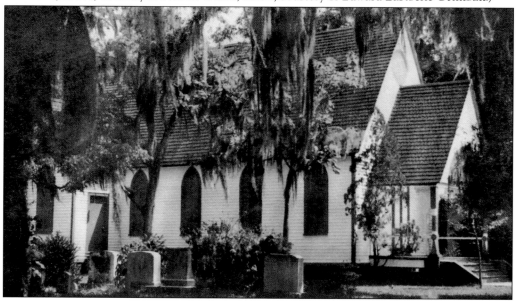

The sixth St. James Episcopal Church building was built in 1960. (Courtesy of Gresham and Carole Meggett.)

The Rev. Charles F. Duvall (left) and William Ellis McLeod, owner of the McLeod Plantation, gathered outside of the old St. James Episcopal Church following a Sunday morning service. (Courtesy of John Jerdone Mikell.)

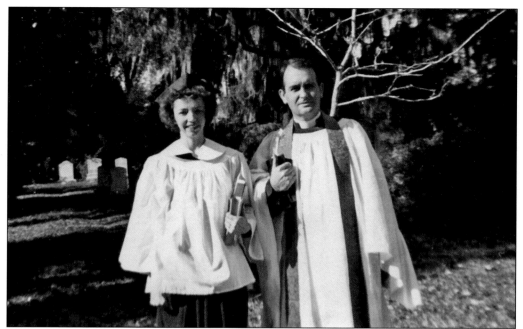

The Rev. Edward B. Guerry was beloved by both of his congregations—that of St. James Episcopal Church on James Island and St. John's Episcopal Church on Johns Island. When the congregation of each of these two churches grew enough to require a full-time pastor, he went to St. John's. He and his wife, Ella, pictured above, spent their latter years as residents of the Bishop Gadsden Community across Camp Road from St. James Episcopal Church. (Courtesy of Gresham and Carole Meggett.)

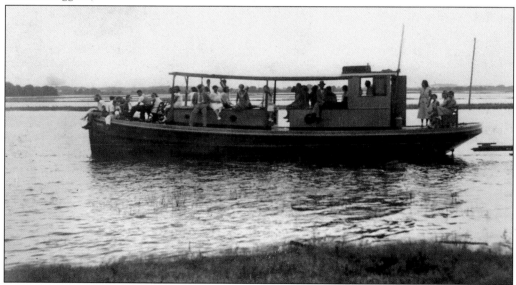

The Christian Endeavor Society implemented the teachings of the church and met on Sunday evenings in the homes of its members to organize missions and collect donations. Shown in 1932 is the Christian Endeavor Society leaving "the Bluff" on Lawton Plantation. (Courtesy of Anna Lebby Campbell.)

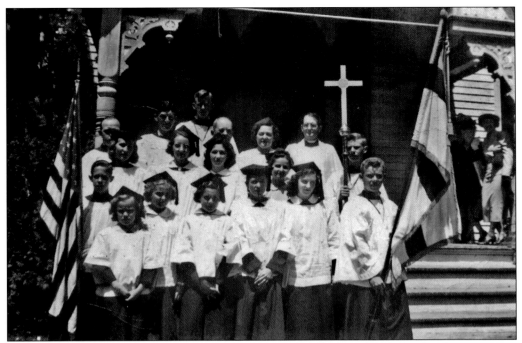

The St. James Episcopal Choir poses for a photograph following the Easter Sunday service in 1949. (Courtesy of Mary Rivers Ellis Staats.)

St. James United Presbyterian Church, established in 1866 by James Island freedmen, was the first church formed by African Americans following Emancipation. The second and current building, built in 1977, is located at the corner of Secessionville Road and Fort Johnson Road at the site of the first construction. (Courtesy of Carolyn Ackerly Bonstelle.)

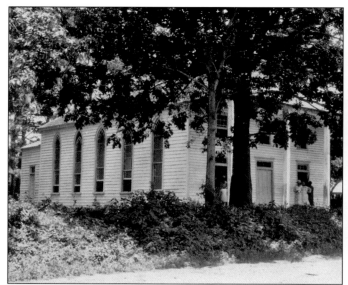

Payne R.M.U.E. (Reformed Methodist United Episcopal) Church was founded in 1869 by James Island freedmen. The church building was renovated in 1962, and the earliest gravestones date from 1949. The c. 1930 photograph above left, taken by William Henry Johnson, shows the first church structure. The Reverend Hercules Champaign, pictured at right in 1994 at his graduation from Cummings Theological Seminary, was the minister at Payne R.M.U.E. Church on Camp Road for 30 years before founding his own church, the James Island United Congregational Church on Signal Point Road, in 1997. The current minister of Payne R.M.U.E. is Rev. Thomas Junious. (Above left, courtesy of the South Carolina Historical Society; above right, courtesy of Rev. Hercules and Mildred White Champaign.)

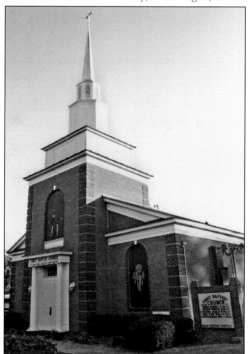

The Baptist Church of James Island at the corner of Camp Road and Dills Bluff Road was built in 1870. (Courtesy of Carolyn Ackerly Bonstelle.)

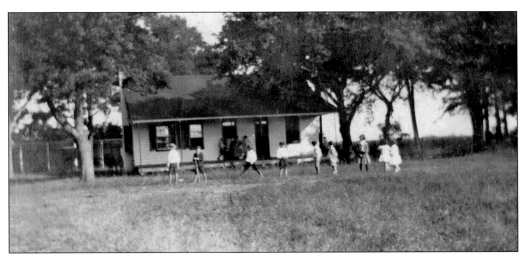

In 1883, the first white public school on James Island was started with six children enrolled; two Royall children and two McLeod children were among them. The teacher, Bessie Jacobs, was a daughter of the Presbyterian minister, the Rev. Ferdinand Jacobs. The school room, which was a portion of the magistrate's office, was located at the junction of Camp Road and the King's Highway (present-day Fort Johnson Road). There were only five school-age children on the island at the time, so one five-year-old, Robert Oswald Royall Sr., was enrolled in order for the teacher to be paid with county funds. In 1884, a two-room school building with a large front porch, a wood room at the rear, outhouses, and a shed in which to "park" the horses students rode to school was built on land donated to the community of James Island by William Godber Hinson. Pictured in 1910 is the schoolhouse built in 1884, which was in use until 1913. (Courtesy of Anna Lebby Campbell.)

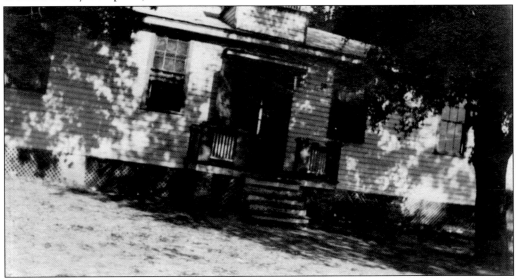

In 1913, the old James Island Grammar School building was moved to Sol Legare Island to be used as the fourth James Island school for African American children. A new two-room building with two restrooms was erected on the same site as the first building. Pictured in 1922 is this second building. Until 1930, when the Riverland Terrace School was opened, the James Island School was the only school for white children on James Island. (Courtesy of Clyde Bresee.)

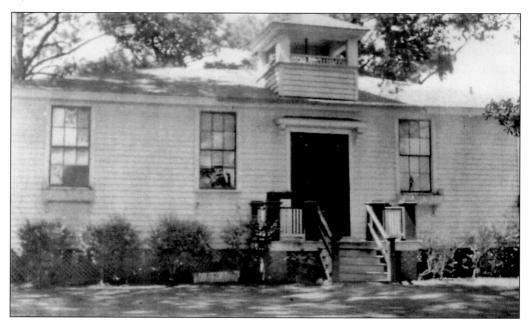

In the early 1930s, an auditorium was added to the 1913 two-room building. Folding doors made this auditorium into two classrooms, which were used continuously. Pictured above in 1938 is this building. Below are students who attended the James Island School that year. From left to right are (first row) Mignon Sullivan, Joy McDonald, and Zelma Haley; (second row) Preston Johnson, Franklin Seabrook, Robert Welch, James Somers Rodgers, and Julian Clark. (Both images courtesy of Frances Mikell Tupper.)

In 1943, a modern six-room frame building was erected on the James Island Grammar School property east of the 1913 building. It was used for the upper grades six through eight. (Courtesy of Dorothy Ellen Royall Ariail.)

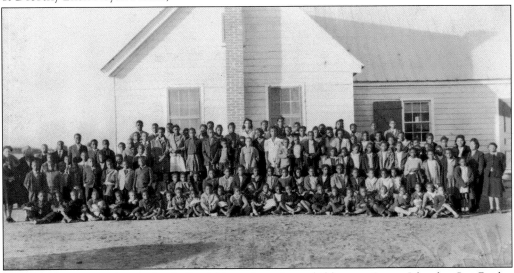

In 1888, there were three schools for African American children on James Island—Cut Bridge Elementary School, Society Corner School (on the corner of Bur Clare Road and Secessionville Road), and Three Trees School (on Fort Johnson Road). In 1913, the school building erected in 1884 for white children on James Island was moved to Sol Legare Island, and Sol Legare School became the fourth school for African Americans on the island. Cut Bridge Elementary School was located on Riverland Drive at the intersection of Camp Road and Cut Bridge on property donated by the Dill family of Stono Plantation. It was originally a two-room school with a cottage in back. In 1955, Cut Bridge was closed and reopened north of its previous site on Riverland Drive as Murray LaSaine Elementary School. Pictured are the students of Cut Bridge Elementary School in 1945. (Courtesy of the Avery Research Center.)

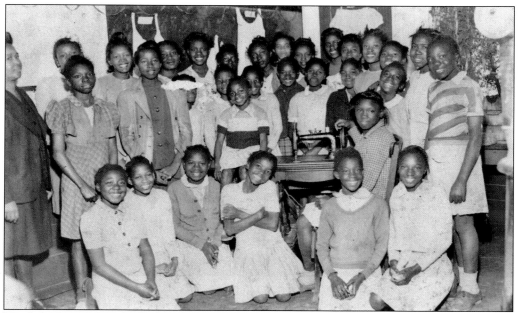

Until the late 1950s, the highest level of public education most African American residents on James Island received was the eighth grade. Only students who could afford to travel to downtown Charleston either by boat or automobile could pursue higher education. Therefore classes such as this 1945 sewing class at Cut Bridge Elementary School, taught by Lula White, were highly valued in preparing young students for a useful and needed vocation. (Courtesy of the Avery Research Center.)

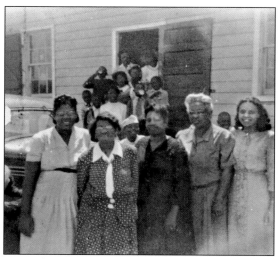

Pictured in 1945 is the faculty of Cut Bridge Elementary School. (Courtesy of the Avery Research Center.)

This beauty pageant contestant won Miss Cut Bridge during the James Island school's Field Day ceremonies in 1941. (Courtesy of the Avery Research Center.)

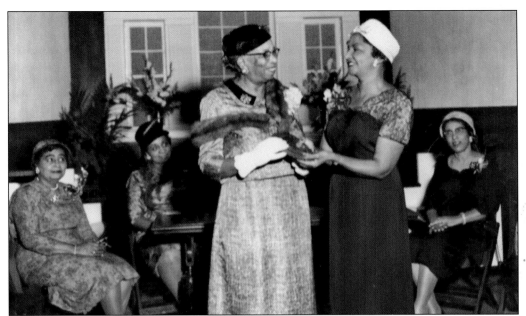

Albertha Johnston Murray (1889–1969), pictured standing on the left, was a Charleston area teacher and principal for nearly 50 years. After graduating from Claftin University in 1909, she taught at Humbert Wood Public Elementary School on Johns Island and at several area schools before accepting the position of principal at Cut Bridge Elementary School on James Island, where she served for 32 years. In 1955, Cut Bridge Elementary School was updated and reopened as the Murray LaSaine Elementary School in honor of Murray and Dr. M. Alice LaSaine, a former supervisor of the Negro Schools of Charleston County. Pictured in 1958, Albertha Murray received the Woman of the Year Award from the Charleston Chapter of Links—a nonprofit women's organization with chapters in 40 states and across the world that was founded in 1946 to provide assistance to African American females. (Courtesy of the Avery Research Center.)

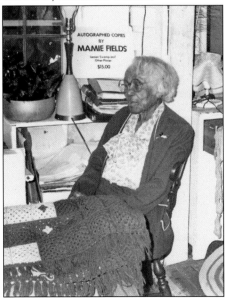

In 1908, after graduating from Claflin University, Mamie Garvin Fields (1888–1987), pictured, and her sister, Hattie, established the first African American school in Pinewood, South Carolina. Following a career as a teacher at Johns Island's Humbert Wood Elementary School and as principal at Miller Hill Elementary School, Fields relocated to Society Corner School on James Island in 1926. In 1983, she authored *Lemon Swamp and Other Places: A Carolina Memoir*, which tells of her experiences as an African American woman living in the South following the war. In her chapter entitled "A School at Society Corner, James Island," she describes her time as a teacher at James Island's Society Corner School, one of four elementary schools for African Americans on the island at the time. (Courtesy of the Avery Research Center.)

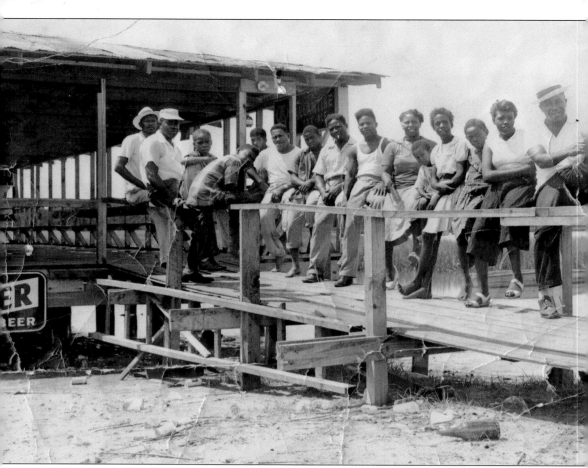

Following the War between the States, James Island freedmen settled on land that once constituted the plantation property of the prosperous James and Johns Island planter and Charleston merchant Solomon Legare. On this area along the Stono River, they farmed small tracts of land and made homes for themselves. Their descendants continued this lifestyle until well into the mid-20th century when James Island began to lose its rural way of life. This area, known as Sol Legare after its last owner, is actually an island of about 860 acres. It is still a primarily African American community, as many of the residents have retained the land passed to them by their post-slavery ancestors. Shown in 1938, Sol Legare Island's Mosquito Beach was a popular recreation site for Lowcountry African Americans who were unable to use the area's segregated oceanfront beaches until the late 1960s. (Courtesy of the Avery Research Center.)

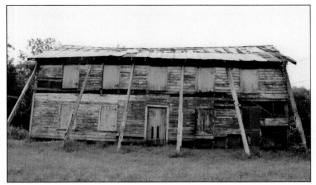

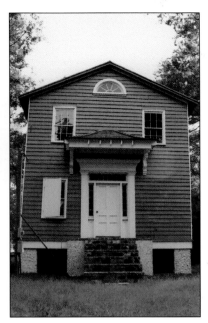

The Seashore Farmers Lodge (above left) on Sol Legare Island was built around 1915 on land purchased from Henry Wallace. Though it still stands today on Sol Legare Road, it is in disrepair, as shown in this 2007 photograph, although funds are being raised to restore it. The King Solomon Lodge (at right) on Riverland Drive was established around 1920. These lodges once held a variety of functions—weddings, numerous social ceremonies, and funerals—in its community. (Both images courtesy of Geordie Buxton.)

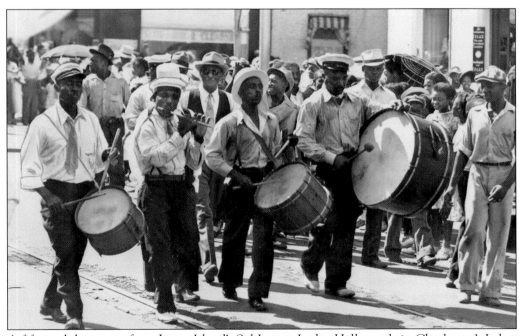

A fifer and drummers from James Island's Sol Legare Lodge Hall march in Charleston's Labor Day Parade on September 6, 1938. Pictured from left to right are: ? Wilder, George Richardson, Benjamin Richardson, and Wilson Jackson. (Courtesy of the *Post and Courier*.)

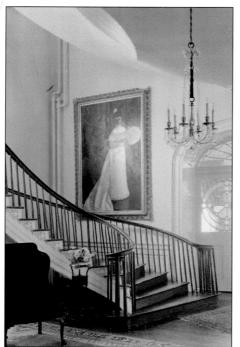

The Motherhouse of the Sisters of Charity of Our Lady of Mercy is located in the maritime forest at the end of Fort Johnson Road on James Island. The sisters moved to the privacy of James Island from their previous location, the Nathaniel Russell House (at left) in downtown Charleston, in 1908, following a series of structural problems caused by the great Charleston earthquake of August 31, 1886. The north door behind the free-flying staircase was the entrance to their building of classrooms that housed over 120 students from the 1870s to 1901. Concerned about the lack of basic education for orphans and other children in Charleston, Bishop John England founded this religious community in 1829 as the Sisters of Mercy. As the congregation grew and moved into missions in Georgia and North Carolina, it adopted the rule of St. Vincent de Paul and changed its name to Sisters of Charity of Our Lady of Mercy in 1949. The sisters continue to serve the poor through ministries in education, health care, and social services regionally and in missions to foreign continents. (Courtesy of the Library of Congress.)

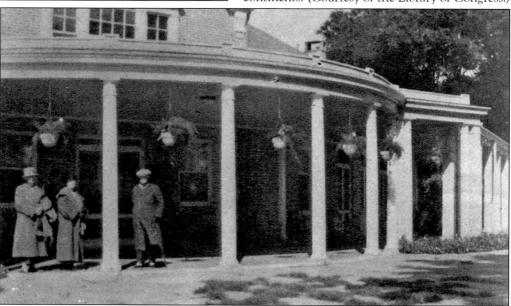

The South Carolina Golf Club—now the Country Club of Charleston on James Island—was originally founded in Charleston in 1786. It is the nation's oldest golf club. Until 1925, when the Country Club opened at its new James Island location on land purchased from McLeod Plantation's W. E. McLeod, it was located on the Charleston Neck, north of Charleston. The golf course at the Country Club, overlooking the Ashley River, is one of two courses on James Island. The City of Charleston Municipal Golf Course, opened in 1929, is located on either side of Maybank Highway, overlooking the Stono River. (Courtesy of the South Carolina Historical Society.)

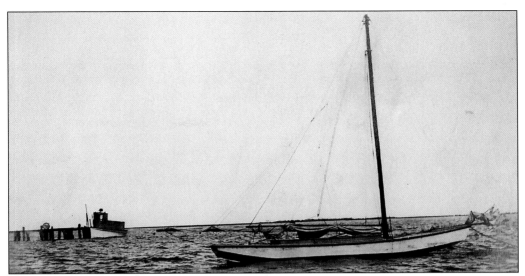

On July 4, 1898, the James Island Yacht Club was officially established. The most significant conclusion of the first meeting was that a new boat be built to represent the island. Reynolds Jenkins, overseer of Sandiford "Sandy" Bee's Lighthouse Point Plantation, was charged with the important duty of constructing this first vessel, *Lizzie B*, which would premier in the 1899 Rockville Races. Named in honor of "Sandy" Bee's young daughter, Elizabeth, the *Lizzie B* overcame her competitors in the 1899, 1900, 1902, 1904, 1905, and 1906 Rockville Races. Pictured in 1904 are the Bees' powerboat, *Surprise* (back left), and *Lizzie B* in Clark Sound at Lighthouse Point. (Courtesy of Capt. Sandiford Stiles Bee Jr.)

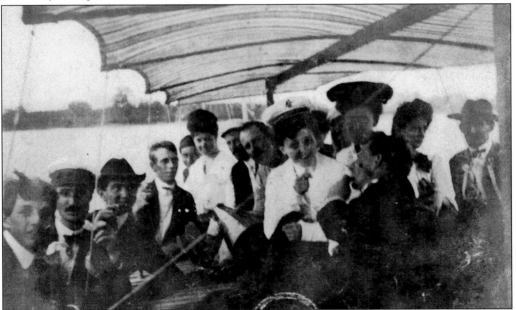

James Island spectators at the 1904 Rockville Races sit under an awning atop the freight boat *Surprise*, which was owned by James Island's Sandiford Bee. The *Surprise*, so named because of its lack of sails, was one of James Island's first powerboats. (Courtesy of Capt. Sandiford Stiles Bee Jr.)

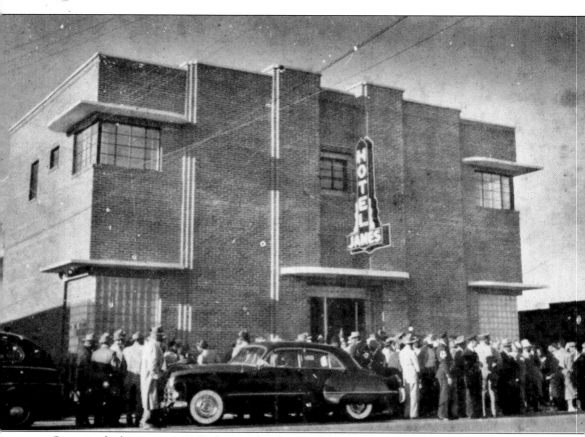

Opening for business in 1952, James Island native George Washington's Hotel James on Spring Street in downtown Charleston was a prestigious venue for African American entertainment and accommodated numerous prominent African Americans, including James Brown and Hank Aaron. The hotel consisted of 20 rooms, a bar, two lounges, and the Azalea Ballroom Limbo Room. The Hotel James was operated by George Washington and his family until it closed in 1979. (Courtesy of the Avery Research Center.)

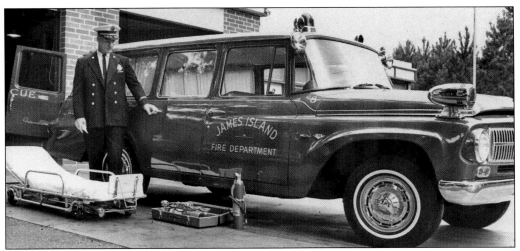

A James Island fire chief checks his gear outside his fire station along Camp Road in 1962. All appears to be accounted for except the Dalmatian. (Courtesy of the *Post and Courier*.)

Melvin Champaign, nephew of James Island's Rev. Hercules and Mildred Champaign, gave his life in duty in the tragic Sofa Super Store fire that claimed the lives of nine heroic Charleston firefighters on June 18, 2007. It was the greatest loss of American firefighters in a single incident since the loss of the firefighters who fought to save lives at New York's World Trade Center on September 11, 2001. (Courtesy of Rev. Hercules and Mildred White Champaign.)

James Island has historically been a land and society defiant of interference from outside governments—from the Federal government in the 19th century to the city of Charleston in the 20th century. This 1973 photograph of a political sign on Folly Road shows the battle James Island continues to face over being incorporated and annexed by the city of Charleston. (Courtesy of the *Post and Courier*.)

Dr. Julian Thomas Buxton Jr. and his wife, Anne Wallace, step out of the St. Christopher Episcopal Church doors in Spartanburg, South Carolina, on their wedding day in 1960. In 2004, the bridge over James Island Creek on Harbor View Road was named in memory of Dr. Buxton, who raised his family on North Shore Drive. The compassionate physician was noted for his bedside manner and extensive house calls to people in the James Island community. For many years, he accepted payment in the form of home-grown produce, seafood, and artisan crafts. He was praised by both black and white families for being the first doctor to treat an African American at Charleston's segregated Roper Hospital in 1967. Anne Wallace Buxton still lives in the family home along James Island Creek. (Courtesy of Anne Buxton.)

Six

FAMILY

Family has always been important to James Islanders. The value of family ties is evinced in many ways—in the significance placed upon family names, the tradition of family gatherings, and in the affectionate practice of giving nicknames. Even today, as the number of non-native families on James Island continues to increase, the names of many of the island's first and most significant families are represented as street names.

For James Islanders, family also means more than ones relatives or ancestors. Whether bonded through marriage, camaraderie during war, or the love of the island, James Islanders have always looked out for each other, sharing with and caring for their brethren in times of need.

Because geography plays such a vital role in the shaping of a person's character, the influence of James Island has endured through generations of families and through the molding of relationships and family chronicles.

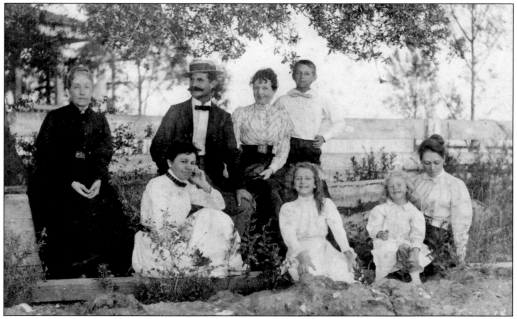

Pictured around 1900 from left to right are members of the Grimball family on their plantation along the Stono River: (seated) Kate Grimball, Beulah Grimball, Burmain A. Grimball, and Rosie Grimball; (standing) Sarah Bailey Grimball, Henry Bailey Grimball, Lula Grimball, and Raymond Grimball. (Courtesy of Frances Robinson Frampton.)

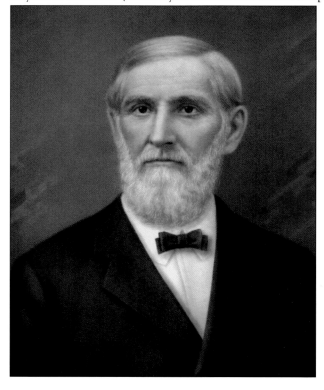

Pictured is Robert Themosticles Lawton, born 1807, father of Cecilia Lawton, who married Winborn Wallace Lawton. (Courtesy of Willis J. Keith.)

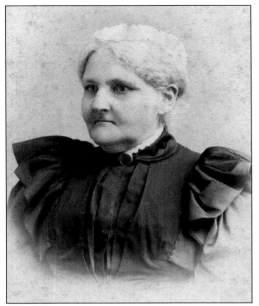
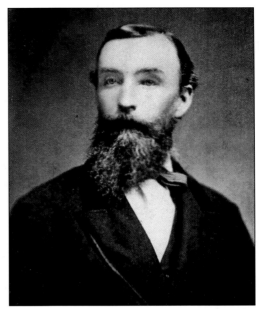

Anna Lawton Oswald, pictured at left in 1895, was the wife of Robert Oswald (right), and the eldest child of Robert T. Lawton and Harriet Singleton Lawton. (Courtesy of Gresham and Carole Meggett.)

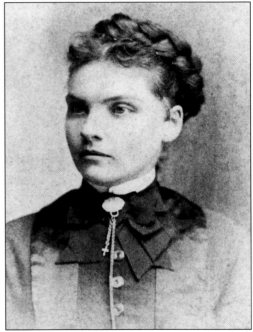

Calhoun Clark (pictured left), the son of Ephriam Mikell Clark, and Lavinia Oswald Clark (pictured below), the eldest daughter of Robert Oswald Jr. and Anna Lawton Oswald, were married in 1872. This marriage between James Island's Clark and Oswald families was one of many island unions that brought prominent planting families closer together. (Courtesy of Mary Seabrook Oswald Godbold.)

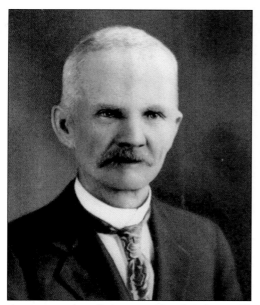

As a young boy living outside of Atlanta, Georgia, Dr. Daniel Wordsworth Ellis (1853–1928), pictured left, stood by the side of the road and watched Federal general William T. Sherman's army pass by after capturing Atlanta on its famous march to the sea in 1864. The Ellis family moved from Atlanta to James Island following the War between the States and began planting on land along James Island Creek. Dr. Ellis married Mary Seabrook Rivers Ellis (1869–1937), pictured right. She was the daughter of Capt. Elias Lynch Rivers and Cornelia Seabrook Rivers. Their marriage joined the Rivers and Ellis families, both of whom owned plantations on the island. (Courtesy of Mary Rivers Ellis Staats.)

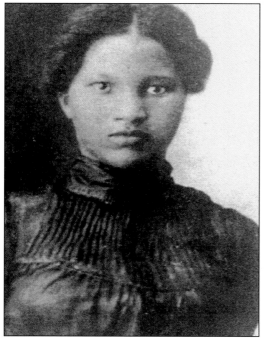

Lillie McNeil Wilder (pictured), daughter of Daniel McNeil and Blanche Prioleau McNeil, was born on James Island in 1887. Her father was born in 1841 as a slave in St. Stephen, South Carolina, and moved to James Island's Sol Legare Road following the abolishment of slavery. Her maternal grandfather, James Prioleau, became a property owner in 1878 when he purchased 114 acres around present-day South Grimball Road. (Courtesy of Avery Research Center.)

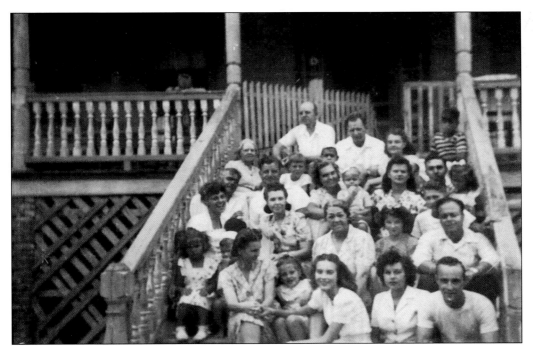

This *c.* 1940 photograph shows the family of Cecil Lawton Oswald and Jennie Rivers Seabrook Oswald on the steps of their home at Oceanview Plantation on Clark Sound. (Courtesy of Mary Seabrook Oswald Godbold.)

The wedding of Daniel Wordsworth Ellis Jr. and Anna Swinton Welch on July 1, 1937, was held at the home of the bride's parents. Pictured from left to right are Mary Sanders Welch (maid of honor), Daniel Wordsworth Ellis Jr., Anna Swinton Welch, Marion Bee King (best man). (Courtesy of Mary Rivers Ellis Staats.)

Anna ("Kitty") and Dr. Daniel Ellis enjoy James Island's natural beauty, surrounded by towering live oaks, in their garden at Ellis Plantation on Folly Road in 1959. (Courtesy of Mary Rivers Ellis Staats.)

The Keith family poses around 1943 on the car of Robert E. Welch, outside the home of Estelle Royall Keith on Clark Sound. Pictured are Robert Ellis Welch, Willis J. Keith, John A. Keith, Rosa Royall Keith, and William Hinson Royall Jr. (Courtesy of Anna Lebby Campbell.)

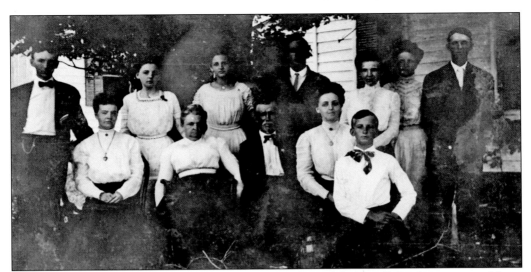

Taken in 1910 at Cornish Farms on James Island, members of the Royall family are pictured from left to right: (seated) Jessie Lockhead Royall, Rosa Oswald Royall, Croskeys Royall Jr., Anna Royall Lebby, and William Hinson Royall; (standing) Robert Oswald Royall, Cecile Royall Welch, Estelle Royall Keith, Calhoun Clark Royall, Rosalyn Royall Calloway, Gertrude Hinson Royall, and Croskeys Royall III. (Courtesy of William Hinson Royall Jr.)

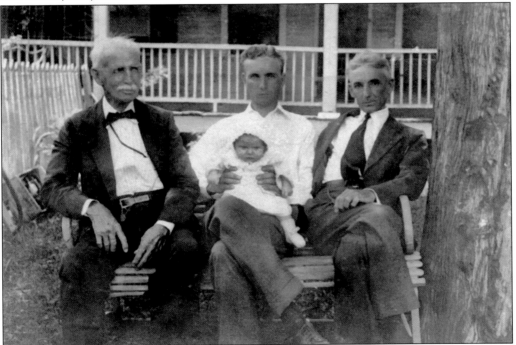

Pictured in July 1932 are four generations of the Royall family. In front is five-month-old Dorothy Ellen Royall, nicknamed "Monkey" in her childhood years. Behind her, from left to right, are Croskeys "The Dude" Royall Jr., great-grandfather of Dorothy; James Perroneau Royall, father of Dorothy; and Robert Oswald Royall Sr., grandfather of Dorothy. (Courtesy of Dorothy Ellen Royall Ariail.)

The wedding of Dorothy Ellen Royall and Clyde Milton Ariail in June 1954 was held at James Island Presbyterian Church, and the reception was held outside on Clark Sound at the Cottage Road home of her aunt Annie Royall Harper. Pictured from left to right are John Roper Bryan, Dorothy Cunningham Royall Bryan, Elizabeth Louise Royall Bartlett, Perroneau Lockhead Royall Blakney, Jessie Lockhead Royall, Clyde Milton Ariail, Dorothy Ellen Royall Ariail, Floyd Rabon Harper, Annie Royall Harper, Katherine Louise Royall, and Robert Oswald Royall Jr. (Courtesy of Dorothy Ellen Royall Ariail.)

Sunday dinner was a tradition on James Island for which family members gathered after church. Pictured around 1948 from left to right are members of the Mikell family at Stiles Point after one of these weekly dinners: (first row) Benjamin Stiles Mikell, John Jasper Mikell, Frances Dill Mikell, Dorothy Agnes Mikell, Hinson Lebby Mikell, Julian Paisley Mikell, Julie Hills Mikell, and Agnes Wallace Mikell; (second row) Edward LaRoche Grimball, Pauline Lockwood Mikell, George Lee Mikell, Julia Paisley Mikell, George Lee Mikell Jr., Dorothy Ale Mikell, William Hinson Mikell Sr., Cecile Lebby Mikell, and Eva Griffin Mikell. (Courtesy of Frances Mikell Tupper.)

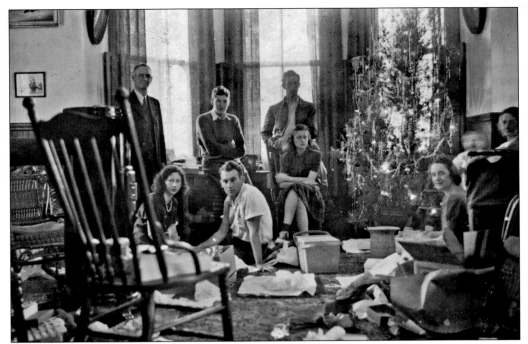

The Mikells and Grimballs pose for a picture after opening Christmas gifts together at Stiles Point in 1941. Pictured from left to right are (seated) Pauline Mikell Grimball, Edward LaRoche Grimball, Katherine Jerdone Mikell, Eva Griffin Mikell, Harriet Lebby Mikell, and Cecile Lebby Mikell; (standing) William Hinson Mikell Sr., Benjamin Stiles Mikell, and Hinson Lebby Mikell. (Courtesy of Lavinia Mikell Thaxton.)

The family sits on the steps at Stiles Point around 1948. Pictured from left to right are: (first row) Pauline Mikell Grimball, Edward LaRoche Grimball Jr., and Lavinia Mikell; (second row) William Hinson Mikell Sr., Pauline Mikell Grimball, William Hinson Mikell Jr., Eva Griffin Mikell, and Edward LaRoche Grimball. (Courtesy of John Jerdone Mikell.)

During the long, hot days of summer on James Island, the porch was a favorite place for visiting with family and friends. Pictured in the summer of 1954 are Cecile Lebby Mikell (at left) and Julia Mikell LaRoche on the porch at Stiles Point. (Courtesy of Pauline Mikell Grimball.)

Family and friends gather in the summer of 1936 at Stiles Point Plantation. Pictured from left to right are (first row) Benjamin Stiles Mikell, Pauline Lockwood Mikell, Florence Turner Hitchner, and Julian Paisley Mikell; (second row) Frances Dill Mikell, Louisa Scott, and Katherine Wall. (Courtesy of Frances Mikell Tupper.)

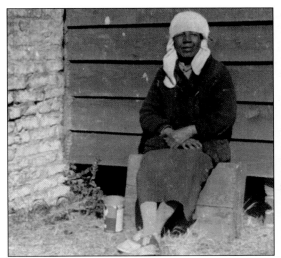

Born April 15, 1888, in Charleston, Louisa Townsend Scott is pictured at left in front of her home on James Island. Louisa married Wilhmon Scott in 1905 and worked at Stiles Point Plantation until the 1960s. As the cook, she had one of the two best jobs on the plantation and was very respected by her peers. She was an excellent cook and began her mornings bright and early in the kitchen. Starting the large, old, iron, wood stove, Louisa would make a pot of hominy and coffee, fry sausage, eggs, bacon, or fish, and gradually the heat from the stove would heat the kitchen. She was a devoted member of Payne R.M.U.E. Church, and upon her death in 1967, Louisa was laid to rest in the Payne cemetery on James Island. In the image above right, Julia Lucas Mikell (left) presents Louisa with a Christmas gift in the old kitchen. In the background is the old wood stove that Louisa preferred to use over the more modern electric stove. (Both images courtesy of John Jerdone Mikell.)

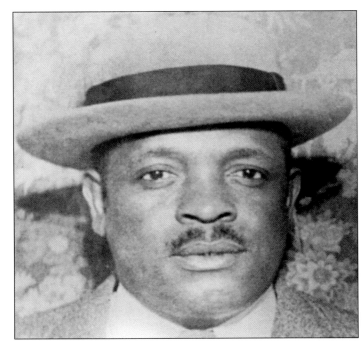

George Washington was born on May 1, 1898, on James Island. He was the son of Edward Washington of Virginia and Celia Brown of Monroe, Alabama. Educated in public schools on James Island, Washington married Georgianna Geddis, and they produced daughters Alethia and Ruth. After the death of his first wife, he married Hattie Powell, with whom he had a son, Edward. Today a Washington street exists on the island. In 1952, Washington established the popular Hotel James in downtown Charleston. (Courtesy of the Avery Research Center.)

The Mikell children entertain themselves by playing marbles outside their home at Stiles Point. Pictured are Katherine "Kitsy" Mikell, Pauline "Pal" Mikell Grimball, Hinson Mikell, and John Mikell. (Courtesy of John Jerdone Mikell.)

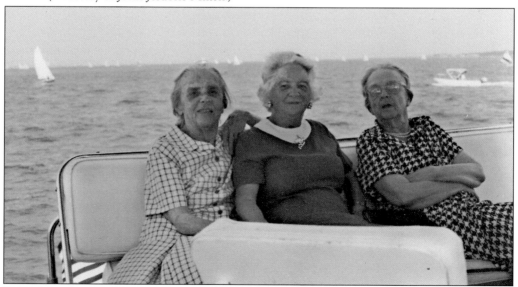

Two of the three Dill sisters, owners of Stono Plantation, enjoy the Rockville Races. Pictured from left to right are Pauline Rivers Dill, Julia Mikell LaRoche, and Frances Dill Rhett. (Courtesy of Lavinia Mikell Thaxton.)

The family of Fuller King managed Stono Plantation from 1925 to 1940. Pictured from left to right at Stono in 1938 are (first row) Lebby King, Hazel King, little Hazel King, Lillie King, Mary Leize King, and Cecile Lebby Mikell; (second row) Fuller King, Ruth Bresee, Pauline Lockwood Mikell, and William Hinson Mikell. (Courtesy of Pauline Mikell Grimball.)

The extended family of Park Mikell, who managed Stono Plantation from 1940 until the 1970s, enjoys Sunday dinner at the plantation in 1944. Pictured from left to right are (first row) Mildred Mikell, Cecile Lebby Mikell, Dorothy Mikell Fishburne, and William Mikell; (second row) Julia Mikell LaRoche, Jenkins Mikell, Pauline Mikell Grimball (with her daughter "Pal"), Park Hay Mikell, Lee Mikell, Julia Paisley Mikell, and Dorothy Ale Mikell. (Courtesy of Pauline Mikell Grimball.)

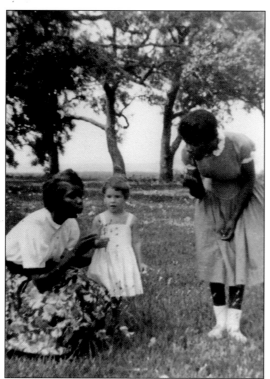

Pictured from left to right are Margaret Ann Smalls, Jane Wallace Wannamaker, and Addie Roosevelt at Stono Plantation. (Courtesy of Frances Mikell Tupper.)

Mary Hood Clark and Julian Hinson Clark, son of Ephriam Mikell Clark, are pictured in 1961. (Courtesy of Mary Clark.)

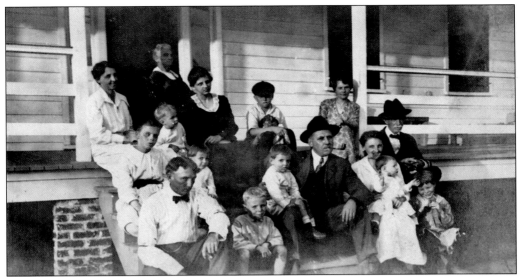

The Royall and Keith families celebrate Thanksgiving at Stiles Bee's Seaside Plantation in 1919. (Courtesy of Anna Lebby Campbell.)

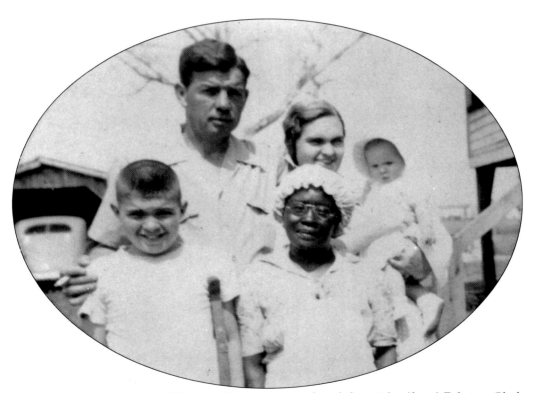

Pictured c. 1943 at the Oswald home at Oceanview are, from left to right, (front) Ephriam Clark Seabrook Jr. "Sonny", Susie; (back) Ephriam "Ephie" Clark Seabrook, Anna Seabrook Oswald Seabrook, Cecilia Anne Seabrook

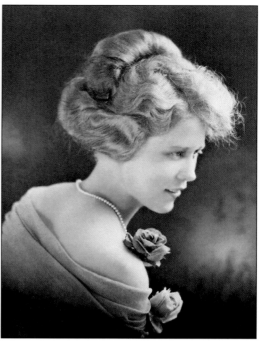

Pictured at left in 1921 is Stiles Bee, the son of Sandiford Bee and Edith Greer Bee. In the 1890s, his father began planting at James Island's Light House Point Plantation. First he planted primarily Sea Island cotton, but he turned to truck farming and dairy products in the early 1920s. Continuing the family tradition, Stiles planted on James Island's Seaside Plantation. Ann Stock Bee (pictured at right) was his wife. (Courtesy of Capt. Sandiford Stiles Bee Jr.)

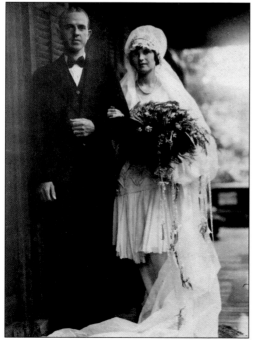

This is the wedding photograph of Wilmer Gresham Meggett and Lilla Seabrook Oswald. (Courtesy of Gresham and Carole Meggett.)

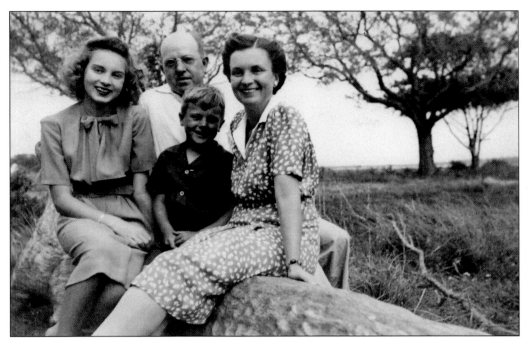

Pictured from left to right are Jennie Leize Meggett, W. Gresham Meggett, W. Gresham Meggett Jr., and Lilla Oswald Meggett. (Courtesy of Gresham and Carole Meggett.)

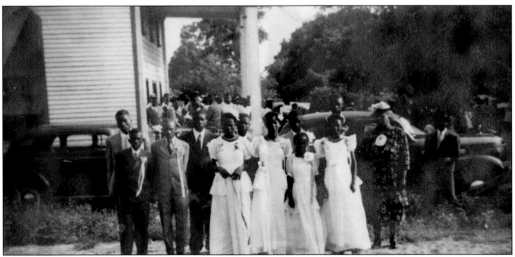

Members of the 1948 Cut Bridge graduation class, surrounded by proud family and friends, pose for a photograph in their graduation dress following the ceremony, which was held at Payne R.M.U.E. Church. Pictured from left to right are (first row) Alonza Brown, Louis Simmons, Hazel Reid, Janie Young, Joyce Pinckney, Mary Brown, and A. J. Murray; (second row) Oscar Brown, Allen Brown, Benjamin Richardson, Jonathan Pinckney, and George Simmons. (Courtesy of the Avery Research Center.)

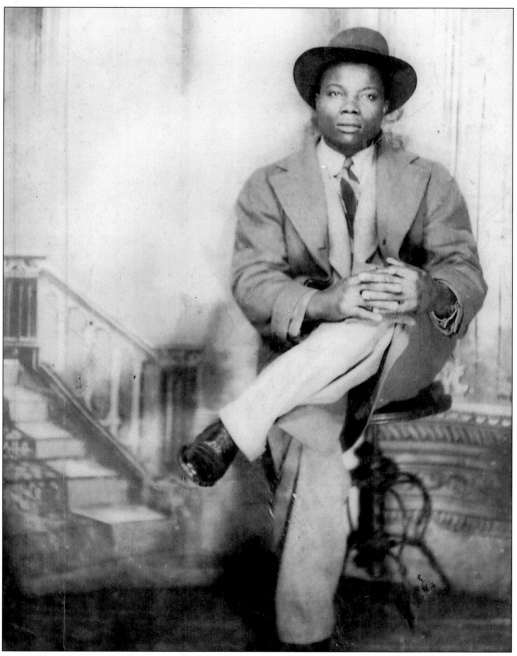

Pictured is Thomas Backman Sr. (1919–1964), a son of Richard and Janie Richardson Backman. He was born on James Island, where he and his family worked on a farm. His knowledge and love for the sea led him to pursue a career on the water, and he began running shrimp boats for local fishermen. Together, he and his wife, Susie Brown, founded Backman Seafood, Inc., and in 1952, they purchased their first trawler. (Courtesy of Thomas Backman Jr.)

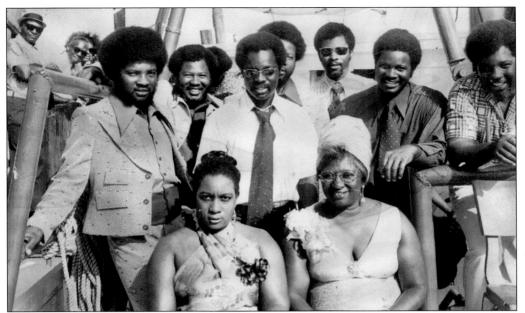

Members of the Backman family celebrate at the induction of Backman Seafood's newest trawler, *Elizabeth*, in 1971. By the 1980s, the Backmans' fleet of trawlers had increased to six, making it one of the largest and most successful fleets on the East Coast. Pictured from left to right are (first row): Elizabeth Richardson and Susan Backman; (second row) Freddy Backman, Joseph Backman, Thomas Backman, Sammy Backman, David Backman, Reginald Backman, and unidentified. (Courtesy of Thomas Backman Jr.)

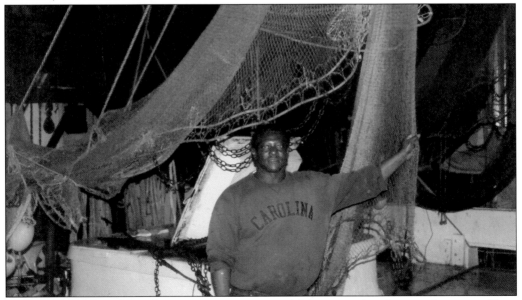

William "Billy" Goss began his career as a commercial fisherman when he was nine years old on Sol Legare Island in 1963. Pictured in 2007 on a trawler in King Flats Creek along Sol Legare, Billy still carries on the maritime tradition of many generations of James Island families. (Courtesy of William Goss.)

Katherine Wall, daughter of Katherine Lebby Wall of James Island and Arthur Davenport Wall, is pictured here in 1941. (Courtesy of Pauline Mikell Grimball.)

Sisters Doe (at left) and Cindy Jenkins enjoy pony rides on unpaved North Shore Drive and Waites Drive in 1964 at the birthday party of their four-year-old sister Pam. Their parents, Drs. Louie and Margaret Quante Jenkins, raised five daughters in their James Island Creek home: Cindy, Doe, Pam, Karen, and Amy. (Courtesy of Amelia E. Jenkins.)

The seven children of Anne and Julian Buxton sit on the brick steps of their porch facing James Island Creek in 1975. In the foreground are two-year-old twin brothers, Jim and Geordie. Also pictured are, from top left, Tiger, 14; Annie, 13; Bill, 5; Lucy, 11; and Eddie, 8. (Courtesy of Lucy Buxton Lukens.)

Geneva Geathers Grant, the daughter of Abraham and Henrietta Geathers, was born on James Island on October 12, 1924. She received her education at Cut Bridge Elementary School and married Edward Grant Sr. on January 5, 1944. From this union, eight children were born: Carolyn Logan, Mary Brown, Juanita O'Kieffe, Carolyn Pinckney, Muriel Grant, Edward Grant Jr., Gilbert Grant, and Perry Grant. A beloved friend of many, including the Reverend Hercules Champaign and Franklin Prioleau of Payne R.M.U.E. Church on Camp Road, Geneva Grant served as district president of the Missionary Board of the R.M.U.E. Churches of the Charleston District until she retired in 1995 due to a leukemia illness that eventually took her life on January 31, 1996. In this c. 1980 photograph, Geneva has just arrived from her Flemming Road home and enjoys a cup of sweet tea on Julian and Anne Buxton's back porch along James Island Creek. (Courtesy of Perry Grant.)

Growing up on James Island, Rev. Hercules Champaign (center) attended Three Trees Elementary School on Fort Johnson Road from first to seventh grade. He fought in the Korean Conflict in 1951 before returning to James Island to work as a carpenter until he was called into the ministry in 1967 at the age of 37. In 1994, he graduated from Cummings Theological Seminary. After serving as minister at James Island's Payne R.M.U.E. Church on Camp Road for 30 years, Reverend Champaign founded his own church, James Island United Congregational, in 1997. While the church has been located on Signal Point Road for the past 10 years, but construction for a new James Island United Congregational Church building is currently underway on Old Military Road. Champaign Street, located off Fort Johnson Road on James Island, is named for Reverend Champaign's father. Pictured in front of the Camp Road home of Reverend Champaign and his wife, Mildred White Champaign, is the Champaign family. Not present for the photograph was daughter Lisa Juanita McKuery. From left to right are Hercules Champaign Jr., Karen Debra, Carl, Rev. Hercules Champaign, Mildred White Champaign, Eugene Bernard White, and Leonard Keith. (Courtesy of Rev. Hercules and Mildred White Champaign.)

Seven

LIFE ON THE WATER

James Islanders have traditionally worked out their daily routines according to the rhythm of the tides. The tides' ebb and flow has directed their lives since the island's first settlers arrived. Residents have always been intimately tied to the saltwater and marshes. Transportation of plantation produce to the mainland, boating, fishing, shrimping, crabbing, hunting, and even travel have all been functions of the tides. Even with two drawbridges in place in the 20th century, James Islanders have little choice in how they arrange their routines. Islanders put out nets and lines from their backyards to catch their meals—crabs, shrimp, many of varieties of fish, and even turtles. Marsh hens and other birds hiding beneath oaks, in cassina bushes and amongst marsh grass, were flushed out by the high tide for hunting. For a maritime society that dared to enter the uncertainty of the Atlantic Ocean, the Morris Island lighthouse has played an integral role in guiding their watercraft, from commercial trawlers to the Mosquito fleets. With their lives inextricably linked to the water, James Islanders have been at the mercy of coastal storms and hurricanes for centuries, compelled to live by the rules of these unpredictable forces of nature.

In conjunction with the way James Islanders have utilized the water for survival, the island's surrounding waters have also always been cherished as an exciting and mysterious playground for children, as well as for adults. For most of its existence, James Island has been easier to reach by boat because it was only accessible by automobile from the Stono River and Wappoo Creek drawbridges, whose priorities were maritime traffic. In 1992, a four-lane connector was built under the supervision of Mayor Joseph Riley of Charleston, making James Island a seven-minute drive from downtown Charleston. Since then, the town of James Island has seen rapid commercial development and remains in fluctuation with its heritage, the water, and development.

Dr. Robert Lebby Jr. was present on April 12, 1861, at Fort Johnson to witness the shot that began the War between the States. He served as a surgeon for the Confederate Army during the war, and later he served for nearly 28 years as the quarantine officer for the port of Charleston at James Island's Fort Johnson Maritime Quarantine Station. (Courtesy of Lavinia Mikell Thaxton.)

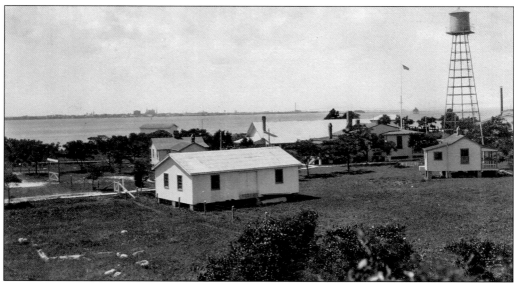

After the War between the States, the area at Fort Johnson served as a quarantine station operated jointly by the city and state, protecting the area against contagious diseases such as yellow fever, smallpox, cholera, and malaria. In 1906, the federal government took over the facility and continued to use it as the quarantine station for the port of Charleston until the 1930s when the site was disposed of as surplus property. It was acquired jointly by the College of Charleston and the Medical College of South Carolina. In about 1970, the S.C. Wildlife Department took title and established their Marine Resources Research Center. This c. 1930 photograph, taken by William Henry Johnson, shows the station from the top of Fort Johnson's powder magazine with a view of Charleston in the distance. (Courtesy of the South Carolina Historical Society.)

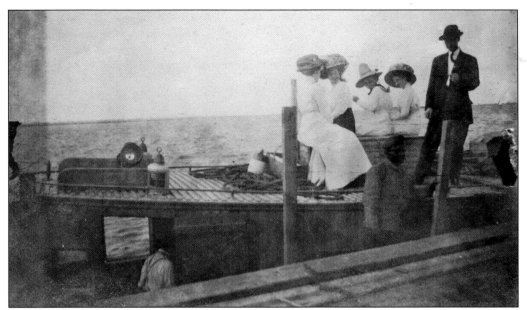

Until the 1920s, ferries and boats were the primary means of travel from James Island to Charleston. The Wappoo Bridge, connecting James Island to the mainland, was constructed in 1926, and even after this bridge was built, a boat trip from James Island across the harbor to Charleston was much faster and more comfortable than a bumpy car ride over the island's unpaved dirt roads. Shown is a typical Saturday's trip into town in which the launch—a motorboat with an open or half open deck—packed full of people and produce, transported islanders to Charleston and returned them to James Island's public wharf or plantation docks in the afternoon. (Courtesy of Anna Lebby Campbell.)

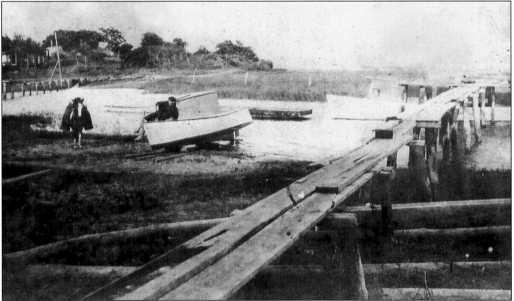

Pictured around 1900 is a footbridge to cross the creek from Oyster Point on Clark Sound to Lighthouse Point. (Courtesy of John Jerdone Mikell.)

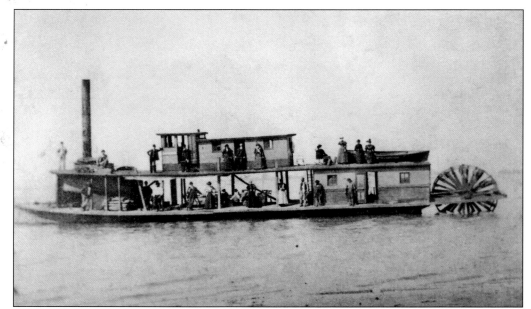

Pictured around 1894 is the Stono River steamer *The Maggie*, with the Grimball family and friends aboard celebrating a family birthday. The photograph was taken from Henry Bailey Grimball's yard on the bank of the Stono River. (Courtesy of Frances Robinson Frampton.)

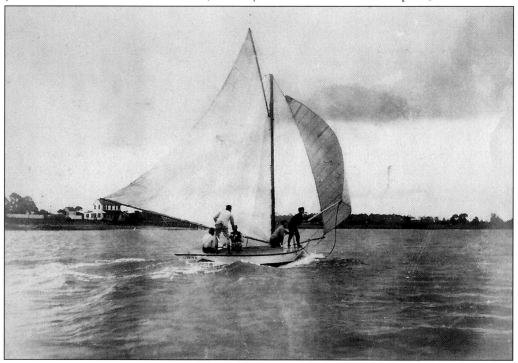

The *Lizzie B*, owned by Sandiford Bee and representing the James Island Yacht Club at the Rockville Races, is pictured here in 1904 in Bohicket Creek at Rockville. A portion of Rockville, Wadmalaw Island, can be seen in the background. (Courtesy of Capt. Sandiford Stiles Bee Jr.)

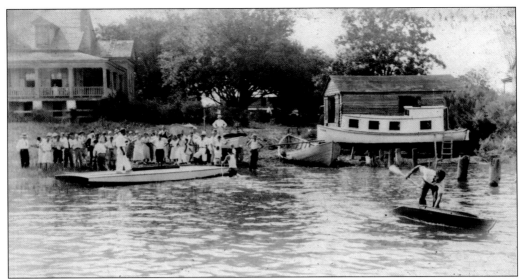

On June 7, 1934, after three years of inactivity, members of the James Island Yacht Club met to reactivate the organization and realized the need for a new boat. The name for this vessel, *Cygnet*, was suggested by Edith Bee, wife of the late Sandiford Bee, the club's founding commodore. In July 1934 at the Secessionville Plantation of Franklin Pierce Seabrook, the newly elected commodore of the club, a crowd gathered to witness the maiden launching of James Island's *Cygnet* into Secessionville Creek. (Courtesy of Anna Lebby Campbell.)

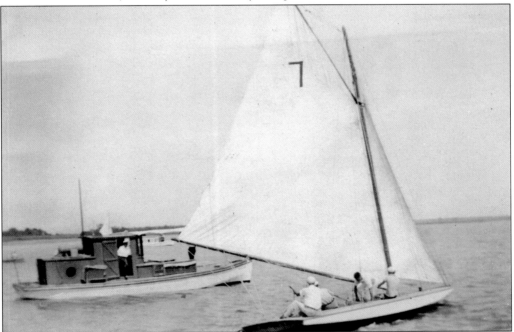

The yacht *Dixie Farm* of Edisto Island (pictured in the background), owned by Capt. Teddy Bailey, escorts the *Cygnet* of James Island out of the Bohicket Creek toward Point of Pines during the 1936 Rockville Races. The crew consists of Dr. Daniel Ellis (skippering), Gresh Meggett, Hinson Mikell, and George Oswald. (Courtesy of Mary Rivers Ellis Staats.)

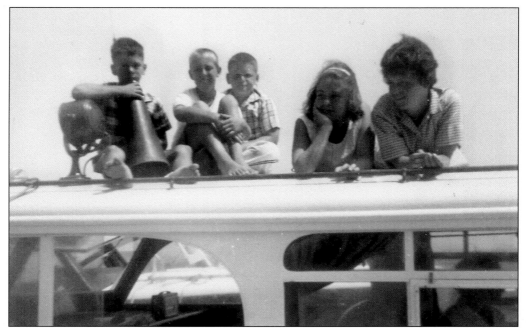

All of the Sea Islanders—James, Johns, Wadmalaw, and Edisto Island residents, both young and old—attended the annual Rockville Races, in which neighboring Sea Islands raced their sailboats. Pictured at Rockville in Park Mikell's boat, the *Nifty*, are James Islanders (from left to right) Daniel "Danny" F. Fishburne III, E. Bruce LaRoche, James "Jamie" Lockwood Tupper, Dorothy Mikell Fishburne, and Frances Dill Tupper. (Courtesy of Frances Mikell Tupper.)

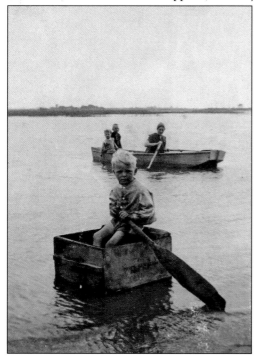

For James Islanders, living on the water has provided a continual source of entertainment and a frequent venue for displaying one's resourcefulness. A favorite hobby of children was to craft their own boats, typically from discarded household containers and shipping crates. Shown in Clark Sound around 1920, seven-year-old Robert Oswald Royall Jr. tests the water, paddling a boat of his own design, as onlookers behind speculate as to whether it will sink or float. (Courtesy of Anna Lebby Campbell.)

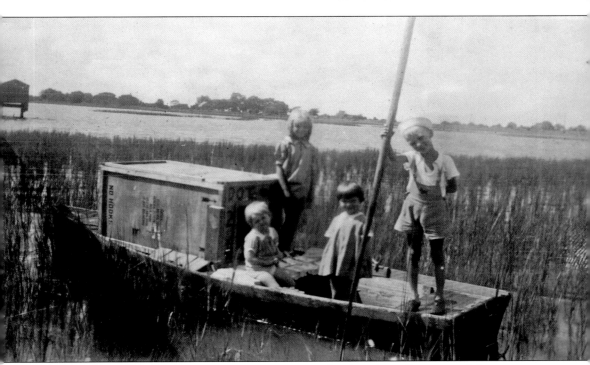

Following the prototype of their predecessors, in 1939, the three Royall sisters and their cousin conceived a watercraft unprecedented by their peers in both luxury and function. Using a large, wooden refrigerator crate, which they secured from their aunt, they added a cabin to their once uncovered boat, dividing it into two rooms—a kitchen for making refreshments and a parlor in which to serve these refreshments. This innovative vessel was aptly named *The Dot and the Billy* after its young architects, Dorothy "Dot" Royall and William "Billy" Royall. Pictured on Clark Sound from left to right are (first row) Elizabeth Louise Royall, Perroneau Lockhead Royall, and William Hinson Royall Jr; (second row) Dorothy Ellen Royall. (Courtesy of Dorothy Ellen Royall Ariail.)

Park Mikell of Stono Plantation returns home from a successful duck hunt. In the background are his duck blinds made of marsh grass, which are used by hunters to conceal themselves. In addition to waterfowl hunting on James Island, Park and his fellow hunters often traveled to neighboring Edisto, Fripp, Kiawah, and Hunting Islands. A native James Islander, Park knew the rivers, creeks, channels, ocean, and tides, and he always seemed to know where the ducks were to be found. (Courtesy of Frances Mikell Tupper.)

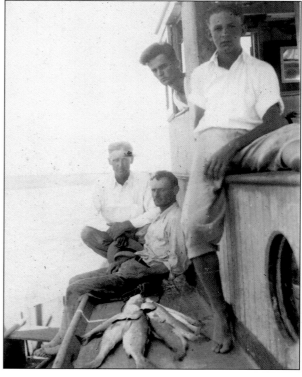

In addition to being an important source of income for many island residents, fishing has always been a favorite leisure activity for James Islanders. Pictured in 1931 from left to right are Julian Hinson Clark, Thomas C. Welch, Daniel W. Ellis, and Thomas C. Welch Jr. (Courtesy of Anna Lebby Campbell.)

Water sports have been a continual source of recreation for island residents. Pictured in 1935, Robert E. Welch and Croskey Welch enjoy their homemade aquaplane on Clark Sound. (Courtesy of Anna Lebby Campbell.)

A young John Mikell navigates his boat home to Stiles Point around 1953. The Fort Sumter House on Charleston's Murray Boulevard is barely visible in the background. (Courtesy of John Jerdone Mikell.)

A dexterous Edward LaRoche Grimball Jr. makes a cast net for shrimping in the island's many creeks. Hanging the net from a hook attached to the wall on his porch, Grimball spent around 25 hours skillfully knitting each net. A single net has approximately 40,000 knots, and every one must be precisely made with equal tension for the net to turn out right, making the creation of a cast net something of an art. (Courtesy of Pauline Mikell Grimball.)

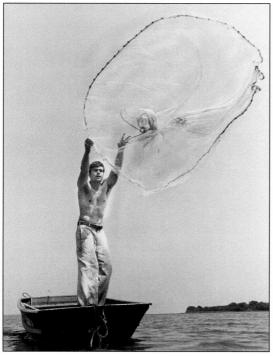

Baynard Seabrook Godbold casts for shrimp on Clark Sound around 1970. (Courtesy of Mary Oswald Godbold Davis.)

Julian Hinson Clark Jr. casts for shrimp in 1931 on James Island Creek. (Courtesy of Anna Lebby Campbell.)

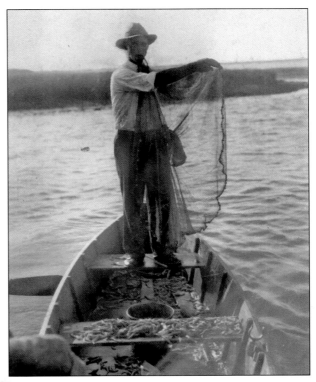

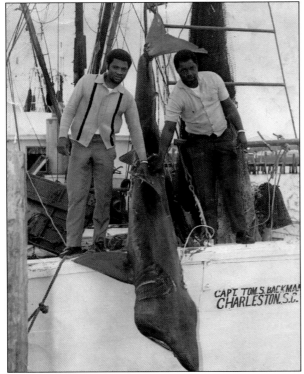

Two members of the Backman family proudly display the massive shark they have just caught. (Courtesy of Thomas Backman Jr.)

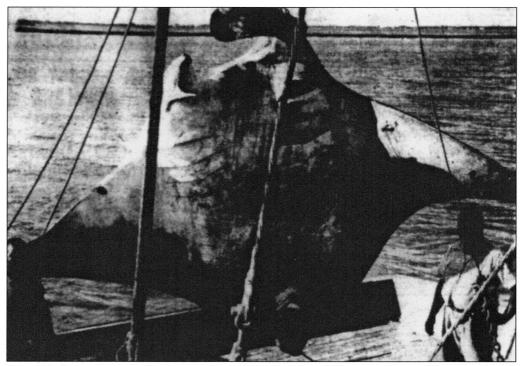

Buster Walker and Thomas Backman of James Island are dwarfed by a giant Manta Ray ("Devilfish") hanging from the boom net of their trawler Benny Boy. They hauled the monster fish in with their shrimp net off of Folly Beach on September 28, 1954. The catch made the front page of newspapers the next day. The big fish weighed nearly 3,000 pounds and was 18 feet long at the wings. Its eyes, located behind the horn-like protuberances behind a mouth large enough to swallow a man, were five feet apart. The fish, a female, gave birth to a 29-pound baby ray while on deck of the James Island trawler. Captain Backman took nearly a bushel of shrimp from the creature's mouth while cutting it out of the shrimp net. The giant ray was donated to Bears Bluff laboratory for research before being tossed back into the sea. Captain Backman's son, Thomas Jr., is a commercial shrimper living on Sol Legare Island today. (Courtesy of the *Post and Courier* and the Charleston County Public Library.)

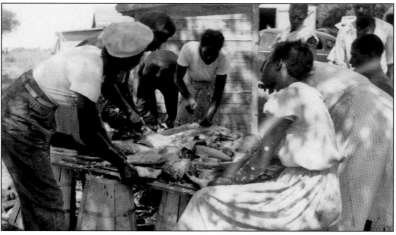

Islanders clean mackerel and other fish on a makeshift table consisting of a crate and wooden buckets turned upside down. (Courtesy of John Jerdone Mikell.)

James Island children always become acquainted with the water at an early age. One of the many available water-related activities on the island is crabbing. In this 1978 photograph, Mary Seabrook Oswald Godbold teaches her grandchildren, Matthew and Jennie Davis, to crab on the family's dock on Clark Sound. (Courtesy of Mary Oswald Godbold Davis.)

Jennie Rivers Davis, home from Clemson University on her Christmas vacation, picks oysters in Clark Sound just outside of her family's Oceanview Plantation home in 1995. (Courtesy of Mary Oswald Godbold Davis.)

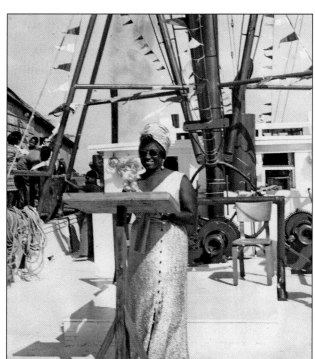

Susan "Susie" Brown Backman inducts the family trawler, *Elizabeth*, in 1971. (Courtesy of Thomas Backman Jr.)

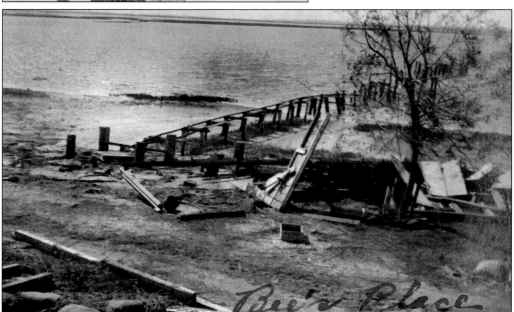

One of the few disadvantages of living on the water is the certainty of severe weather. Until 1950, when forecasters began using names for tropical storms and hurricanes, storms were simply remembered by the year in which they occurred. In 1911, a hurricane hit Charleston with 105-mile-per-hour winds. Shown here is damage after the destructive storm that was done to the dock of the Bee family's Lighthouse Point Plantation on James Island. (Courtesy of Anna Lebby Campbell.)

The Morris Island lighthouse was once surrounded by land and an elegant, three-story, Victorian keepers house that looked more like a mansion than a home. The lighthouse keeper, his two assistants, and their families lived in it. Livestock, vegetable and flower gardens, and about 15 other buildings made up the complex, which included a small schoolhouse. A teacher came over from the mainland on Monday and stayed until Friday to help with the lessons. Shown in 1938 is what remained of the house after a massive storm. (Courtesy of Anna Lebby Campbell.)

Hurricane Hugo, a destructive, category-five hurricane, struck Charleston in September 1989, after its eye passed over James Island. At the time, Hugo was the most costly and damaging hurricane on record in U.S. history. Shown shortly after Hugo is James Island's Ephriam Mikell Clark House at Oceanview on Clark Sound. (Courtesy of Mary Oswald Godbold Davis.)

The first permanent bridge over the Wappoo Creek was built in 1899. The next Wappoo Bridge connecting James Island with the mainland was constructed in 1926 and was a concrete structure with a steel swing span that opened to let boat traffic through. Its deck was wooden and later covered with asphalt. This c. 1930 photograph depicts the 1926 bascule bridge shortly after it was built. (Courtesy of Anna Lebby Campbell.)

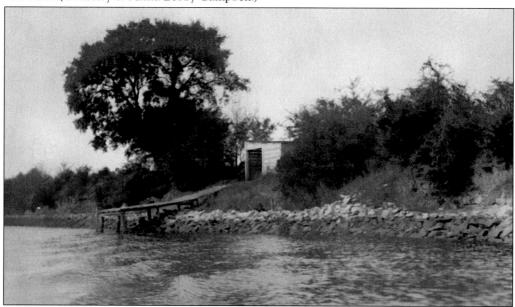

This c. 1930 photograph of Wappoo Creek depicts a simpler time on James Island's busy waterway. Part of the Atlantic Intracoastal Waterway—the inland waterway connection for maritime traffic from Boston, Massachusetts, to Brownsville, Texas—today Wappoo Creek is used as a boater access point and for maritime traffic moving between the Ashley River side of the Charleston harbor to the Stono River that borders James and Johns Islands. (Courtesy of Anna Lebby Campbell.)

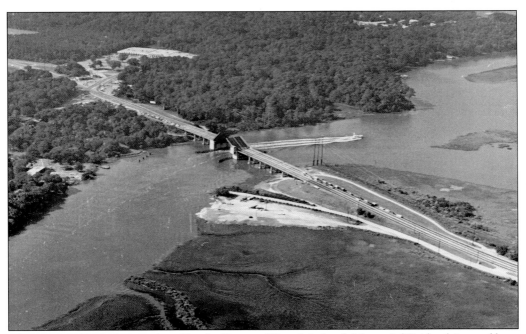

The Wappoo Bridge was replaced by the Burnett Rhett Maybank Memorial Bridge (pictured here in 1967), a concrete and steel structure that was completed in 1956. Maritime traffic was a priority until the James Island connector was built in 1992. (Courtesy of the *Post and Courier*.)

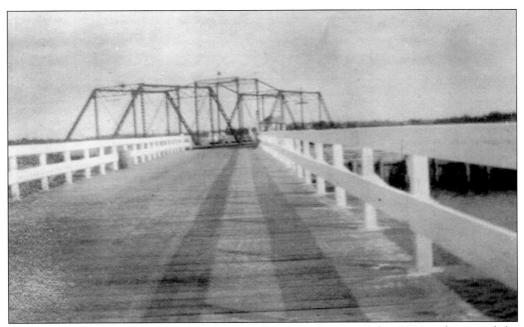

The Stono Bridge on present-day Maybank Highway was constructed in 1929 and spanned the Stono River, connecting James and Johns Islands. This swing bridge was one of the few remaining in the area until it was replaced by the Paul J. Gelegotis Memorial Bridge in 2003. (Courtesy of the South Carolina Room at the Charleston County Public Library.)

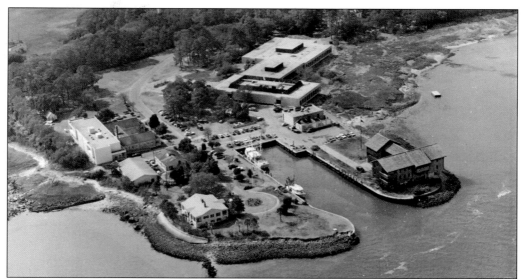

Pictured in 1985 is James Island's Fort Johnson area, which today is mostly occupied by the S.C. Department of Natural Resources Research Center. This multimillion-dollar facility is shared by the College of Charleston, the Medical University of South Carolina, National Oceanic and Atmospheric Administration, and the South Carolina Marine Resources Division. Also on this site is the College of Charleston's Grice Marine Laboratory and the Marshlands Plantation House, which was built around 1810 and moved by barge in 1961 from its original location at the Charleston Navy Yard on the Cooper River. (Courtesy of the *Post and Courier*.)

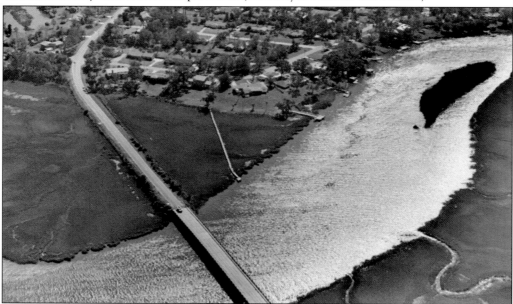

This photograph depicts James Island Creek the spring following Hurricane Hugo, which ripped away many trees and docks with its 138-mile-per-hour winds on September 21, 1989. The Dr. Julian Thomas Buxton Jr. Bridge is in the foreground. Dr. Buxton's James Island family retreated to his brother's home in Sumter, South Carolina, while he stayed and worked through the night as Hugo passed over James Island and Charleston. (Courtesy of the *Post and Courier*.)

James Island resident Tano enjoys the island' amenities daily. Among his favorite activities are boating, swimming, and basking in the sun; however, his island adventures would not be complete without roaming in the island's plentiful pluff mud and relishing the multitude of marsh and marine life. Pictured on the dock owned by his friend Steven Sandifer in James Island's Parrot Creek, Tano prepares for yet another exciting afternoon's exploration of nature. (Courtesy of Carolyn Ackerly Bonstelle.)

DISCOVER THOUSANDS OF LOCAL HISTORY BOOKS
FEATURING MILLIONS OF VINTAGE IMAGES

Arcadia Publishing, the leading local history publisher in the United States, is committed to making history accessible and meaningful through publishing books that celebrate and preserve the heritage of America's people and places.

Find more books like this at
www.arcadiapublishing.com

Search for your hometown history, your old stomping grounds, and even your favorite sports team.